ACKNOWLEDGMENTS

To Jamie Markle, for his unbounded enthusiasm and for going out on a limb for me. And to all the people at North Light Books who supported this concept.

To Kelly Kane, Editor of *Watercolor Magic*, to Anne Abbott, former Editor of *Watercolor Magic* and Maureen Bloomfield, former Senior Editor of *Watercolor Magic* for giving me the opportunity and the forum to explore and share my ideas.

To my special friends and students, who allowed me to use them as guinea pigs and whose gifts to me are too numerous and heartfelt to articulate, especially Jo Toye, Ginny Diaz, Carolyn Hallstrom, Norbert Baird, Kay Thomas, Peggy Sample, Michele Powers, Anna Howell and Sylvia Lovett-Cooper. Although I promise I didn't draw blood, it must have felt like it to them at times.

To my talented and hilarious colleagues in the 22 x 30 critique group: Bob Oliver, Dick Phillips, Betty Braig, Jason Williamson, Tom Herbert, Cindy Peterson, Sebastio Pereira, Michael Goodwin, Trish Mayberry, Diane Maxey, Susan Holefelder, Ron Bergen, Ina May Moore and especially Mary DeLoyht-Arendt, Miri Weible, Grace Haverty and Mickey Daniels, who have given me incredible love and support and have come to my rescue more than once. Thank you to my good friend and fabulous artist Lynn McLain for being my favorite nut!

To Amanda Metcalf, for her laugh and sense of humor as she worked on the format of this book diligently. What a great sport!

To Cindy Rider, a great big thank you for being a jack-of-all-trades with her diligence and persistent help in rounding up information.

And a gargantuan thank you to Vanessa Lyman, the production editor.

To my exceptional friends from Park Central Toastmasters, the funny, the bright and the creatively zany Vanessa Dehne, Terry and Wyatt Earp, Harry Huffman, John Torphy, Nikki Lanford and Tom Cleary. (They actually listen to me!)

To Pierre Guidetti and the great people at Savoir Faire for supplying me with wonderful products and support.

All of you have a significant piece of my heart.

Finally, to all artists of the present and future. May we make this world a more creative and beautiful place, and may we never forget or ignore the sacred light with which we have been entrusted.

ABOUT THE AUTHOR

Betsy Dillard Stroud grew up in Rocky Mount, Virginia in a family with a host of characters straight from the pages of Tennessee Williams, Eugene O'Neill and Noel Coward. When she was eight, an insightful uncle gave her a set of oil paints, and she began to study with a private tutor. Her next artistic phase included drawing frizzy headed women smoking cigarettes (blond with no eyebrows) wearing extremely low-cut bathing suits.

A former art historian, Stroud received her B. A. in art from Radford University and her M. A. in art history from the University of Virginia, where she was the first woman in the graduate arts program. She had just completed her course work and her orals for the doctorate when she wrote her first book—changing her life forever.

Since 1987, Stroud has conducted workshops and judged exhibitions nationwide. Her work hangs in collections all over the United States, and also in Japan, England, Australia, Canada and the Bahamas.

Stroud is a signature member and Dolphin Fellow of the American Watercolor Society and holds signature status in the National Watercolor Society and the Rocky Mountain National Watercolor Honor Society. A professional writer, Stroud has authored three books, most recently Painting From the Inside Out (North Light, 2002). She has written for magazines for the last nineteen years and for the last five has been contributing editor to Watercolor Magic. When not painting, writing, playing the piano, ballroom dancing, watching movies or going to Park Central Toastmasters, you can find her daydreaming. She lives in Scottsdale, Arizona with her new bad cat, Hamlet.

DEDICATION

I dedicate this book to the divine creative spirit that embraces and unites us all.

And with love and gratitude to my talented friends, writers Maureen Bloomfield and Robert Joseph Ahola, whose selfless support has stuck to me like glue.

And in memory of my beloved Papa, Judge Peter Hairston Dillard, Jr.

And my precious companions, Scalawag, Edgar and Christmas Tree Stroud, who now romp and bark in the Happy Hunting Ground.

Table of Contents

the
ARTIST'S
Muse

UNLOCK THE DOOR
TO YOUR CREATIVITY

BETSY DILLARD STROUD

NORTH LIGHT BOOKS
CINCINNATI, OHIO
www.artistsnetwork.com

Reverie in Black by Betsy Dillard Stroud (acrylic on hot-pressed paper, 30" × 22"; 76cm × 56cm)

The Artist's Muse: Unlock the Door to Your Creativity. Copyright © 2006 by Betsy Dillard Stroud. Manufactured in China. All rights reserved. No part of this book may be reproduced in any form or by any electronic or mechanical means including information storage and retrieval systems without permission in writing from the publisher, except by a reviewer who may quote brief passages in a review. Published by North Light Books, an imprint of F+W Publications, Inc., 4700 East Galbraith Road, Cincinnati, Ohio, 45236. (800) 289-0963. First Edition.

Other fine North Light Books are available from your local bookstore, art supply store or direct from the publisher.

10 09 08 07 06 5 4 3 2 1

DISTRIBUTED IN CANADA BY FRASER DIRECT
100 Armstrong Avenue
Georgetown, ON, Canada L7G 5S4
Tel: (905) 877-4411

DISTRIBUTED IN THE U.K. AND EUROPE BY DAVID & CHARLES
Brunel House, Newton Abbot, Devon, TQ12 4PU, England
Tel: (+44) 1626 323200, Fax: (+44) 1626 323319
Email: postmaster@davidandcharles.co.uk

DISTRIBUTED IN AUSTRALIA BY CAPRICORN LINK
P.O. Box 704, S. Windsor NSW, 2756 Australia
Tel: (02) 4577-3555

Library of Congress Cataloging in Publication Data

Stroud, Betsy Dillard
 The artist's muse: unlock the door to your creativity / Betsy Dillard Stroud. — 1st ed.
 p. cm.
 Includes bibliographical references and index.
 ISBN-13: 978-1-58180-875-9 (pbk. : alk. paper)
 ISBN-10: 1-58180-875-5
 1. Painting—Technique. 2. Art—Psychology. 3. Creation (Literary, artistic, etc.) I. Title.
ND1473.S76 2007
701'.15—dc22 2006022225

Edited by Amanda Metcalf
Production edited by Vanessa Lyman
Designed by Wendy Dunning
Production coordinated by Matt Wagner

METRIC CONVERSION CHART

To convert	to	multiply by
Inches	Centimeters	2.54
Centimeters	Inches	0.4
Feet	Centimeters	30.5
Centimeters	Feet	0.03
Yards	Meters	0.9
Meters	Yards	1.1

Introduction

> *"One truly understands only what one creates."*
>
> —Giambattista Vico

When I was ten years old, as I wandered through the dusty fairgrounds of Rocky Mount, Virginia, where I grew up, suddenly a gypsy ran from behind the curtains of a nearby tent. She grabbed my skinny arm with an iron-clad grip as her black eyes burned a hole through my palm. In a raspy voice, she whispered in my ear, "You are going to lead an exotic life. You will love and be loved by many men. And, you will travel the world far and wide. In fact, you will lead a double life." She smiled mysteriously and cackled, "You will be married five, maybe six times." She took one long look at me before smiling ruefully again as she abruptly dropped my tiny hand and disappeared behind the folds of her tent.

Perhaps the gypsy saw the lines of tragedy forming in my palm. Perhaps she saw my father's suicide. Perhaps, she recognized the nemesis of all despair—the creative spirit. For, I think she knew, as we all do, that in life, we craft our own script, write our own scenario and choose to follow our dreams or not.

Her predictions came true. I have led an exotic life, traveling far and wide, and my tempestuous relationships and five marriages caused a trusted friend to remark, "Little Betsy, all your life people have been telling you that you look like Elizabeth Taylor, and now, you certainly are trying to act like her." It is what the gypsy didn't tell me, however, that is of real importance.

Perhaps I'll never know what she meant by leading a dual life, but what I do know is that life is a mysterious journey with unexpected endings and beginnings for us all. But a wise man would tell you that it is not what happens to you that matters but how you deal with it. No, the gypsy didn't tell me the whole story.

My Pied Piper drove me from the very beginning as I drew giant murals of owls all over the walls of our living room and scribbled furiously into the bound books my father gave me. My dream of becoming a good artist and a good writer held fast, and I trust it to sustain me for the rest of my life.

To those removed from the artistic life, the word creative might imply a world far, far away—a distant plane inhabited only by the most gifted artists. Enigmatic, unimaginable, and unreachable. Elitist. Let me assure you. Being creative is a natural gift accessible to all. To be creative, you simply open a door, the door of the subconscious mind, and allow thoughts and images to emerge unedited. Then, of course, you must challenge yourself by taking action.

This book contains a series of creative challenges that I wrote over a four-year period for *Watercolor Magic* magazine. Included is a game designed to help you summon your own artistic muse.

Through the creative experience, I discern my basic rhythms and articulate my intricate thoughts. Through my creative experience, I achieve wholeness and unity of spirit. Through the creative elixir called self-expression, I have been healed, inspired and nurtured. Allowing your creative spirit to evolve, you too will have both opportunities and blessings too manifold to count. I encourage you to enter the doors presented in this book with an open mind. See where your brushstrokes lead you. Open yourself to all the experiences that appear. The treasure lies inside us all. We have only to unlock the door, and it will be revealed.

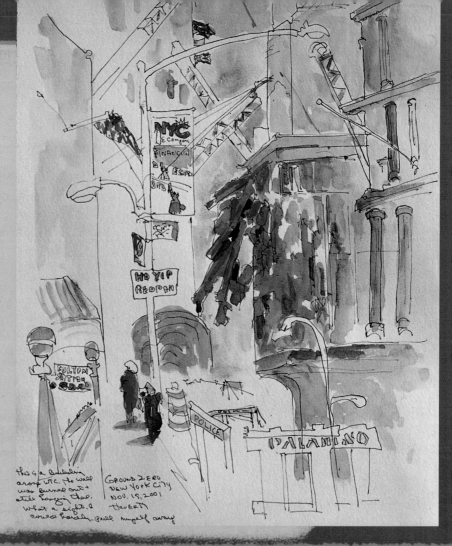

A Response in Image and Words From Ground Zero

Grace Haverty, a fellow artist and good friend, did this sketch, *Ground Zero* (watercolor and ink, 10" × 8"; 25cm × 20cm) on site. Here are her words: "I was drawn to the site and could not leave. On November 15, 2001, the air was thick with an unfamiliar smell. I felt compelled to draw what I saw. There was a pervasive feeling of sadness and emptiness. I found myself looking at each piece of steel hanging from this building, all charred and burned. I imagined the hustle and bustle of September 11 before the tragedy—now only somber quietness. The flags that hung on the building across the street and the one or two people walking down the street made the realization of that day come back in full force. After spending hours on the spot, I left feeling empty, yet with a deeper understanding."

the **Core** of **Creativity**

"September 11, 2001, changed all our lives, yet something inside of us never changes. That immutable something is an incandescent flame. Sometimes it smolders, and sometimes it flares up brightly. But, make no mistake, it is eternal, just waiting to be released. This flame is our creative spark."

—BETSY DILLARD STROUD—

A little more than fifteen years ago, I came across a gem of a book in a Dallas bookstore. It was small, turquoise, standing upright by itself like a stalwart soldier at full military stance. As I walked by, I could have sworn it whispered my name. At the time I seemed to be at an impossible artistic impasse and needed a little inspiration to spark my creativity. "This looks provocative," I said to myself. "Maybe I'll read a couple of chapters before I go to bed." The name of the book was *If You Want to Write: A Book about Art, Independence and Spirit*, by Brenda Ueland. That night I began reading, and as the hours passed, my light stayed on. In the wee hours, by the time I finished the book, I was in a state of inspirational euphoria. It wasn't a gem but a priceless diamond that has taught me, inspired me and nurtured me ever since. Although the book's title suggests that it's aimed at writers, it is also for painters and other creative people. Each page is replete with important revelations about the creative act.

In this piece and the rest of the book, my goal is to probe the nature of creativity—from my standpoint and from the standpoint of other artists. In each section there will be a theme and exercises that I hope will stimulate and motivate you.

WHAT IS CREATIVITY?

Perhaps creativity is indescribable, like a silvery pink reflection on a wave at sunrise. In essence, it is a lot like the word *sacrament*—an outward and visible sign of an inward and spiritual grace. We can recognize it when we see it in other people, but how do we recognize it in ourselves? And, as painters, how can we not lose it as we fall prey to the pressures, obligations and pitfalls of an artist's life? According to Ueland, we are all creative and we are all "talented, original and have something important to say," or paint.

How, then, does she explain this creativity? First, and most importantly, she tells us that a cre-

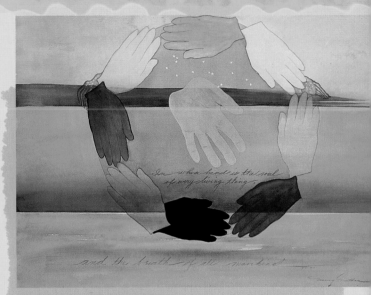

Making Use of a Biblical Text
In this response to the tragedies of September 11, *Our Times Are in His Hands* (watercolor on paper, 22" × 30"; 56cm × 76cm), Nancy Greetham chose to meditate on the text from Job 12:10: "In whose hand is the soul of every living thing, and the breath of all mankind." The different hands represent mankind—each hand representing a show of love to one another. The hand in the center represents God's hand, safe and strong, that holds the sea and guides the stars.

ative impulse is not action-driven—rather, it is idle. It comes from reverie and daydreaming, and not from laboring furiously over something. Second, she tells us that creativity stems from a feeling of love and generosity, an idea she got from a letter Vincent van Gogh wrote to his brother. Ueland writes, "It is a feeling of love and enthusiasm for something, and in a direct, simple, passionate and true way, you try to show this beauty in things to others—by painting it." We can assume then that creativity comes from deep emotion.

Think of some of the greatest works of literature and art. They originate from passionate feelings and sometimes from life's greatest tragedies.

SEPTEMBER 12, THE DAY AFTER

The day after September 11, as we struggled to find a balance and a semblance of order in our

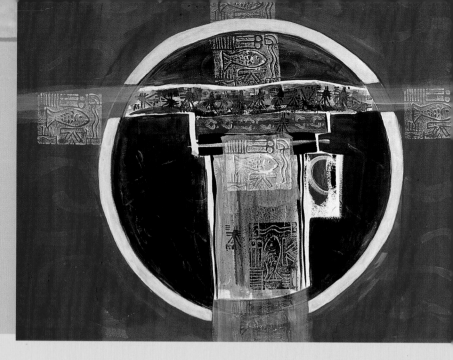

lives, I taught my master class in watercolor and design. We met, all choking back tears, and for the first twenty minutes I asked each student to speak about the tragedy. The other students and I listened as each person expressed his or her deepest feelings. I had already decided that part of my assignment for the following week would be to create a painting about what had happened. Making authentic art requires expressing all that is in us, so how could we ignore this event? By the next week, when the paintings were completed, the outpouring of emotion and content in each of the pieces was overwhelming.

Many of my students responded by creating a mandala for world peace. I had suggested this form because three years ago, as I stood in front of a blank canvas, I had an inspiration to paint a mandala as a meditation on peace. Every brushstroke I made, I said out loud or to myself, "Peace on earth. Goodwill toward men." With that painting I began my "Cosmic Graffiti" series.

MORE ABOUT ❧ MANDALAS ❧

- The mandala, a circular symbol, has been held sacred from ancient times.
- Mandala means "disk" or "circle" in Sanskrit.
- Common interpretations of the symbolism of the circle are: immortality, eternity, unity and wholeness.
- Mandalas can be painted using symbols for things in our lives that we want to heal or make manifest.
- Carl Jung painted a mandala every day to reconcile aspects of his own life and psyche.

A LESSON FROM THE MANDALA
Because the mandala represents completion, I try to make my writing come full circle, too, so here's a postscript to the Ueland saga. Soon after I read her book, I met and became friends with Penelope Niven, author of *Carl Sandburg: A Biography*. In the course of writing her book, Niven interviewed Ueland, who was then on her deathbed, because Ueland had been one of Sandburg's best friends.

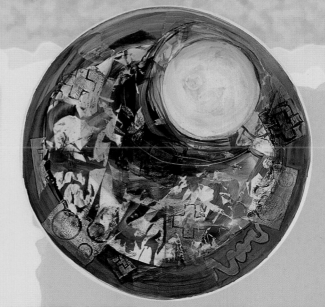

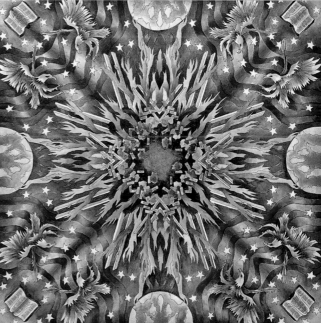

Niven kindly played for me the marvelous tapes of Ueland's wise, crackling voice and gave me a copy of a letter Ueland had written to Sandburg in which she said, "Dear Carl, I am so glad you liked my little book. It is really about the Holy Spirit."

As you do a painting about September 11, 2001, or any other catastrophe since that date, pull out all the stops! Remember, visual images are the most recognizable symbols in the world, transcending barriers of race, religion, country and history. The proper images can be a linchpin to unite us all. And, as writer Robert Joseph Ahola, author of *I, Dragon*, reminds us, "Your painting can be a demon on your back or an angel on your shoulder."

I prefer angels, don't you?

In Response to Tragedy: Symbols of Unity and Love
JoEllen Larsen Layton's striking mandala *Kaleidoscope* (watercolor on paper, 25" × 25"; 64cm × 64cm), above top, radiates from the center like a beam of heavenly fire, supported by angelic figures on the rim. It depicts the artist's belief that we are supported by our faith and love. In *Path to Peace* (watercolor on paper, 30" × 30"; 76cm × 76cm), above, Marilyn Gross shows a world in turmoil and chaos swirling toward unity, wholeness and peace, all symbolized by the glowing circle of golden light. Healed relationships are symbolized by the cross with four arms of equal length.

❧CHALLENGE
⟹*Paint a Mandala*

You'll need sheets of watercolor paper, fresh brushes and containers for water, plus any other materials you want to use, such as stamps or scraps of paper for a collage. Start your mandala or your designated painting after you've centered yourself by either sitting quietly and daydreaming, listening to music or even contemplating nature. Then put into visual form your personal response to September 11, or paint a mandala for world peace. Express it any way you wish, using any tools, any kind of watermedia and/or collage. While you're working, think about the symbols you may want to use in your painting. Perhaps you will be like me and have a painting comprised simply of brush-strokes. Or perhaps you will fill your composition with recognizable symbols, as some of my students did.

⟨1⟩ START WITH A CIRCLE

Trace a circle onto a sheet of 22" × 30" (56cm × 76cm) watercolor paper. I like to use a big round plate to draw the circle.

⟨2⟩ PAINT

Start painting. I painted a rim around the circle using a variety of colors in the analogous range from red-orange to purple. Then I painted a carved stamp with appropriate images using varieties of these colors, plus interference gold, changing the color each time I stamped.

⟨3⟩ GIVE YOURSELF A MANTRA

Say a mantra. Every time I put a brush-stroke or stamp down, I said, "Peace on earth." I decided to add circles inside the circle, tracing around a roll of drafting tape for the outside circles and a small dessert plate and smaller jar cap for the center circles. Repeating "Peace on earth" was an important part of my process. Make no mistake: Thoughts are things and have shapes. Every positive thought about our world situation makes a big difference. By painting a mandala about peace, take note that you are calling forth what is best in the spirit of man. It will make a difference.

Flowers for the Soul

"If you have two loaves of bread, keep one to nourish the body but sell the other to buy hyacinths for the soul," was the excellent advice offered by the Greek historian Herodotus some two thousand years ago. Anne Bagby, who works in watercolor and acrylic, characteristically creates an ornately patterned surface on/against which she places larger shapes, often flowers. In *Paper Whites* (watermedia on paper, 7" × 7"; 18cm × 18cm), the forms of the narcissi, though distinct, are woven into the rhythmic pattern of repetitive linear elements.

the **Spring** of **Creativity**

"I hide myself within my flower,
That, fading from your vase,
You, unsuspecting, feel for me
Almost a loneliness."

═ EMILY DICKINSON ═

What describes spring better than the exquisite colors and fragrances of flowers? But how to capture their elusive grace and fragility? From the first forty years during which I lived in Virginia, my memories are vivid: unimaginable scents and glorious colors; the images of my grandmother's rose garden, a paradise of pinks, lavenders, pale yellows, reds and oranges; the velvet glow of my mother's pansies and her ethereal blue morning glories, like tiny trumpets lifted toward the sun; and then there were my uncle's dark purple-black irises, mysterious and beguiling. They beckoned provocatively, flitting about

in their windblown frocks. I grew up breathing the rich provocative scent of honeysuckle on spring nights, the memory of which will stay with me forever.

Not only did I grow up surrounded by flowers, but in Rocky Mount, Virginia, there are myriad springs hidden in the woods. Behind our house, we spent many a day at Hickory Spring, a dark, cool world, complete unto itself, where we'd swing like trapeze artists on the grapevine over the spring, where my sister, Caroline, slipped off and broke her arm. Those irenic springs remind me of our source, our own spring and well of creativity. They're cool and deep, "tasting of Flora and the country green," according to Keats, and when the sun hits, it's brilliant, a tiny beam of energy that strikes a rock or moss or a tree trunk and illuminates its target swiftly but briefly. Creativity comes in much the same way—like an arrow piercing the sky with speed and accuracy. And its target is to release the creative energy inside us—to share with the world in our own expressive way one of our greatest gifts, nature. Like the haiku, a Japanese poetic form that usually consists of three lines of five, seven and five syllables, you can create the essence of flowers through suggestion and nuance.

PAINTING FLOWERS THROUGH IMPROVISATION: BARBARA NECHIS

Back in 1981, Barbara Nechis introduced me to the world of ambiguity and magic—improvisational painting and allusion versus illusion. As she painted, floating in one color after another, images emerged and color diffusions never imagined came into being. Her painting, at this stage, was a subtle environment composed of soft nuances of

color and amorphous shapes drifting into atmo-spheric washes. Nechis admits, "I don't want to compete with the natural beauty of flowers. The best painted imitations make me long for the real thing. It would be depressing to copy flowers, for the best of imitations can only play second fiddle to the real. I do, then, what the flower cannot do. I use water, edges, color and forms [shapes] and my imagination in ways that real flowers could never attempt.

"Although I am not interested in reporting, I don't ignore reality either, making sure that expres-sive form does not take me too far away from observation. Without actually observing flowers, one might stereotype the floral image, giving it an appearance not unlike the stylized versions found on wallpaper. One of the ways that I work, which I call 'painting with water,' lends itself beautifully to this concept. I may find a lovely bloom in my garden, hold it in my hand and draw its form on a large sheet of Arches paper using clear water. If I like the way it looks, I drop paint into the water and watch the colors merge on the paper. From this beginning, I add shapes as needed—larger,

smaller, a related row and then a change of color or direction, perhaps. Both taking photographs and drawing shapes help me to focus on form.

"It may seem contradictory, but to me obser-vation is the key to being able to make anything abstract. Then I essentially ignore these sources when I work—hoping that my stored vocabulary will lead me to create new images. To express the essence of flowers, their freshness, I avoid any mechanical rendering. Instead, I emphasize strong design patterns both through repetition of shape and an unexpected punch, such as an offbeat shape, color or focal area. My follow-through and detail make the welcome accidents have a refine-ment and form, which add depth."

CREATING A DECORATIVE BACKDROP FOR FLOWERS: ANNE BAGBY

For Anne Bagby, flowers, inserted into her intricately decorated still lifes, are not only artistically beautiful, they are highly symbolic. Her flowers reflect hospital-ity. More importantly, there is the interesting play of stark contrasts—of placing something alive into an arrangement of otherwise inanimate objects. In French, the term for still life is *nature morte* (dead nature). Yet, as Bagby points out, the flowers were once alive. The contrast, therefore, is still there. To explain, she says, "I deal literally and figuratively with the patterns of my life. I attempt to distill the beauty from the lives of women who 'take pains' and who know the meanings of flowers: the corsage, the funeral wreath, the flowers arranged in welcome. My view of flowers is both romantic and emotional, domestic and prosaic."

Bagby begins her process by making several detailed drawings of flowers (she prefers dramatic flowers like the sunflower and the amaryllis) that "address the frame," i.e. touch the edge of the paper at least once on each side. Next comes a wet-into-wet underpainting, covering the entire

Wet-Into-Wet Underpainting
Barbara Nechis started *Flower Quilt* (watercolor on paper, 22" × 30"; 56cm × 76cm) with a wet-into-wet underpainting. She didn't want to tell the whole story of the flowers. Instead of delineating form, she merely suggested it.

Dropping In Color
Janet Walsh creates flowers with diffusions of color dropped in as she paints. In *Sunlit Patterns* (watercolor on paper, 22" × 30"; 56cm × 76cm), she shows an exuberant array of summer blossoms. By leaving parts of the paper white, she suggests the radiance of the season.

sheet, usually in a light midtone value. After this step dries, she covers the selected drawing with clear contact paper in order to make a mask to seal the drawing off. Carefully, she cuts around the drawing with a craft knife, lifting off the negative shape around the flower, so she can paint freely and intuitively over her surface. Then she begins her negative painting process, using acrylic paint and adding texture. This is where her patterning comes in, as she "explores the relationship between flowers and the machine-made container and the ornamental environment." Her resulting paintings are beautifully orchestrated narratives of texture and design with a burnished monumentality—elevating the still life to a different plateau.

MAGICAL DIFFUSIONS: JANET WALSH

"Flowers excite me," exclaims Janet Walsh, popular workshop teacher. "It's that marvelous feeling that I get as I walk through my own garden that I wish to express through my paintings." Walsh paints upright on an easel, and in this position, watercolor makes its special magic, as she paints one color and then drops in another to get the beautiful diffusion she seeks.

Before she begins painting, she selects her subjects and brings them into her studio, putting them in various vases. Then she returns to her garden and snaps Polaroid pictures of her greenery. All her paintings are improvisational in the sense that she artfully arranges her shapes for the strongest design and best color coordination. The pictures are mainly for reference, to help her find a variety of interesting shapes. She develops her background last. Walsh comments, "Even though flower painters are disregarded in the world of art, we use flowers to express all our emotions, whether it be love, grief, excitement or whatever. If you watch flowers, you know that they change color constantly. In addition, irises, roses and peonies have interesting histories. And all flowers have their different personalities, just as people do. It's important to study their specific shapes. The most important advice I can give anybody who wants to paint flowers is 'Learn to look.' It's the outside shape that matters so much."

MAKING THE ORDINARY EXTRAORDINARY: DONALD CLEGG

"My studio is a potpourri of dried berries, seed pods, Chinese lanterns, silver dollars—anything and everything that I grow in my own garden in Spokane, Washington," Donald Clegg confides.

*"A weed is no more than
a flower in disguise."*

⟞JAMES RUSSELL LOWELL⟝

The Integration of Foreground and Background

Donald Clegg paints the foreground directly—wet-into-wet or dry-into-wet. For the background, he applies glazes to suggest subtle modulations in color and value. In *Autumn Medley #5* (watercolor on paper, 14" × 16"; 36cm × 41cm), he repeats the forms in the foreground by recasting them as part of the background.

He combines his love of gardening, cooking and painting into a refined and organized passion. "I have branches of leaves that are three years old," he tells me, laughing. "Eighty percent of my subject matter comes from my own yard. I am a very 'untricky' painter. I use paint tissue and paper. I don't use frisket; I work around white shapes."

His voluptuous watercolors are baroque in their luscious use of color and form combined. "People think the foreground is the most important thing," he continues, "but it's the background that establishes the mood. My process is forthright. I begin with an improvisational foreground done wet-into-wet and render my subject through layers of glazing for temperature changes as I establish light and shadow for textural effects. Painting is a three-legged stool: the technique, the physical process and the content [what you're saying] are the legs, but the stool will topple unless you have a good design."

Finally, Clegg offers those whose fervor to paint

❦CHALLENGE
⇒ *Paint Flowers*

Start with a wet-into-wet underpainting and, like Barbara Nechis, refrain from telling the entire story by merely suggesting forms. Or choose to create a more ornamental environment as a foil to display your flowers, and, like Anne Bagby, use imprinting, stamping and masking for your arrangement. Maybe, like Janet Walsh, you prefer to create your flowers with diffusions of colors dropped in as you paint. Another option is to use an array of bounty, from dried and saved remnants of flowers or from vegetables or fruit right from your own garden, as Donald Clegg does. Perhaps your painting, like his, will be a combination of layering and glazing contrasted with passages of wet-into-wet. Last, if you're hankering for a truly challenging challenge, make a "green painting."

may have cooled this advice: "If you're stuck in a rut, look for those plants and items you feel a physical connection with. (I'm a teapot aficionado and a Depression glass addict.) Play with those objects and then go for a walk. When you come back, arrange those things on a table while playing with the design. I guarantee you'll be ready to paint before you know it." The American poet Mary Oliver wrote, "What happens/to the leaves after/they turn red and golden and fall/away?" Now we know! They're in Donald Clegg's studio.

❧ WHAT TO DO WITH GREEN? ❧

Yes, I know, you've got it, too. It's called the "I can't deal with green syndrome!" Are you relying on tube greens alone? I see lovely blues, reds and yellows in most students' work, but when it comes to green, I have to suspect that there must be countless tubes of Phthalo Green on their shelves. There's supposed to be no Phthalo Green in nature, but, truthfully, there are two exceptions. In the Bahamas, when a wave crests and the sun strikes it just so, there is a brief moment when the light pierces the wave, and it glows an unearthly, beautiful Phthalo Green. And then there's the Emerald Flash, an optical illusion only seen at sea that occurs just as the sun drops below the horizon.

I gave one of my classes the following assignment: Do a painting using nothing but greens, but make your own greens. You may use tube greens also, but you must add another color to that green to gray it down. I painted *A Tribute to Rosimori* (watercolor, 22" × 30"; 56cm × 76cm) from a photograph sent to me by my friend Rose Morey, a painter herself. It provided a stimulating opportunity to play with the color green. Here's my palette: MaimeriBlu watercolors: Permanent Green Yellowish, Permanent Green Light, Indian Yellow, Tiziano Red, Verzino Violet, Indigo, Dragon's Blood, Primary Blue and Sap Green. Yes, you do see red and violet in the palette. Why? Most greens are composed of a smidgen of red, magenta, orange or some other warm color. Take for example, a saguaro cactus. Striations of magenta wander through the cactus. Or, look at a rose closely. You'll see the meandering reds

moving up the stem and into the leaf. And, of course, there are many flowers whose centers are green.

I quickly drew the contour of the flower onto a piece of cold-pressed Arches paper. Then I methodically wet the entire background around the flower and floated in every color mentioned above except Indigo and Dragon's Blood. (I used them later to make dark green foliage, which allowed my flower to "pop out.") By the way, Indigo, Dragon's Blood (or brown madder) and Indian Yellow make a perfect forest green, as my friend and teacher Naomi Brotherton taught me. After the background dried, I painted the center of the flower Indian Yellow and Permanent Green Yellowish, with indications of a shadow painted in Dragon's Blood and Indian Yellow. I created shadows in the white flower by dropping Indian Yellow, Tiziano Red and Primary Blue onto the wet surface.

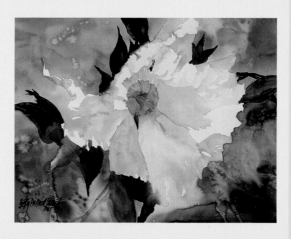

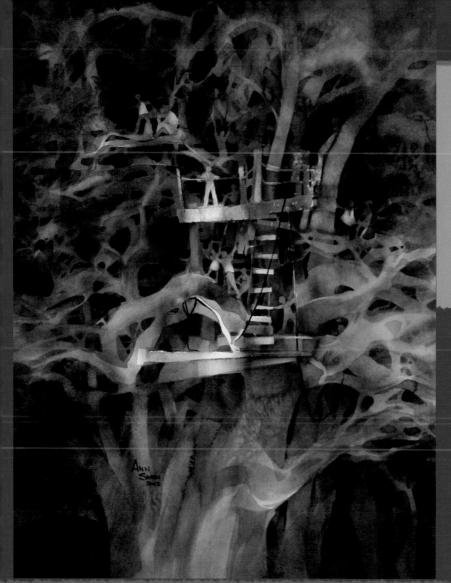

a **Creative Journey** through the **Written Word**

"When a person opens a book, he can never be in prison."

—Victor Hugo—

How often a book, a piece of verse or a quotation can become a catalyst to stoke the "fire in the belly"—the creative imagination. Because of the stories and books that my family told and read to me, my childhood was an unending journey of

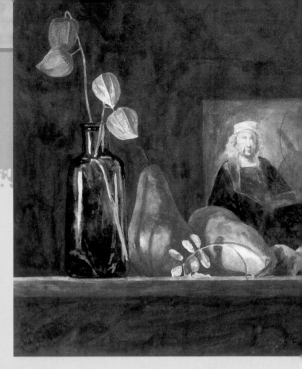

mystery and magic, giving me the greatest gift a child can receive—a love for words, a romance that will continue forever. Some of my earliest sensory memories are of the smell of books, as seductively and elusively fragrant as an ancient cedar chest, a wet blade of grass or the scent of honeysuckle after dark.

After listening to stories at night, I flew to faraway places on my magic carpet drifting in and out of clouds and soaring above the clusters of stars. About the age of nine, when I began to enjoy the act of reading more, I stored my magic carpet in a small but sacred corner of memory, always to be treasured. As do the other artists in this article, I use the power of words to inspire me, and the ability to use this power is unlimited, as you'll see from the examples here.

INSPIRING TALES FROM CHILDHOOD

"The best reward at the end of every day was a good book," Ann Smith remembers. Freshly scrubbed and wearing their pajamas, she and her brother "couldn't wait to hear the next chapter of *Black Beauty*, *The Swiss Family Robinson* or *Treasure Island*." Smith's whimsical, ambiguous paintings about tree houses capture the enchantment of childhood imagination, her passion for her subject and her amazing facility in painting wet-into-wet, a challenging technique. In fact, the source for her tree-house series is the children's book *The Swiss Family Robinson*.

"The process of painting a tree house is exactly the same as building one," she explains. "Just like the Swiss Family Robinson's tree house, my paint-

ings begin with a vision and a heart filled with hope and determination. From the chaos of the Robinsons' shipwreck, useful items are salvaged, necessary things are invented and one step leads to another. Just as in a painting, every mistake requires discovery and courage, and one must take dangerous risks.

"As in painting, the struggle for survival requires faith, resourcefulness and commitment. When in despair, an unexpected new insight restores the soul and the energy to continue work. From an unpromising and tentative early foundation, confidence gradually builds until eventually intriguing new pathways beckon and the sense of adventure grows.

"Fine craftsmanship counts, and elegant but daring design adds strength. Imagination is imperative, and believing in miracles helps. When the tree house is completed, it's hard to stop working on it. Improvements and repairs could go on [for] a lifetime. When I finally leave it and turn around to take a last look, I see that left behind is a completely personal statement reflecting a unique journey. And then it's time to start dreaming up the next adventure."

"In painting a still life, it's important to select objects that reflect your own personality and life," Charles McVicker says. "By doing this, the content of your work comes through." McVicker's choice of color, his thoughtful arrangement of objects and his sensational lighting effects all serve to provide a mood of serenity and intrigue so that the viewer may engage in a delightful visual dialogue with the painting, as in *Our Daily Bread* (acrylic, 22" × 30"; 56cm × 76cm).

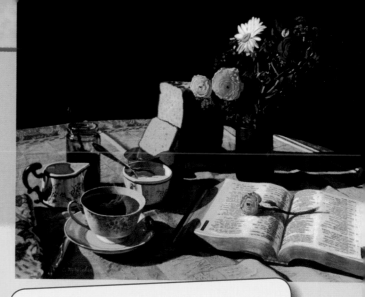

DRAWING ON ART HISTORY

Still life painter Donald Clegg says, "I occasionally pay tribute to other artists in my own painting. I have several books on Rembrandt and I believe his self-portraits, taken as a whole, are perhaps the greatest series of paintings in all of art history.

"Simon Schama's epic biography *Rembrandt's Eyes* made me marvel at the progression of his self-portraits, from images of a pompous youngster to a mature and tragically self-aware man. I decided to include one in a painting of my own, but couldn't decide which to use. Schama's narrative decided for me, describing an aspect of a particular painting that had always puzzled me: 'The painting, after all, was a demonstration, Rembrandt's last, of the vigor of his powers, the authority of his art. He was accused of slighting line, of botching drawing. Very well then: He gave his critics—and his admirers—perfect circles, lines so cleanly and exactly done that they might have been made by Giotto.' Then, as if to say, 'To hell with this mechanical rendering,' he painted much of the rest of the portrait in a blur of half-suggested brushwork.

"Working to incorporate this portrait, I used colors and values more appropriate to the year of its painting, 1662 ... working more in chiaroscuro and thus with a stronger emphasis on light and dark than usual. As my painting is quite small, Rembrandt's head was actually only about the width of my thumb, and getting a likeness in that small an image was a tough challenge.

⬇ CHALLENGE
➤ *Let a Quotation Inspire You*

As I wrote this article, I came across the following quotation in my journal, although I don't know the author: "There are two things in life that affect you more than anything else. The books you read and the people you meet." What inspires you? Pay homage to the writers you love.

Option 1, inspired by Ann Smith:
Think about the first book or poem you remember hearing or reading as a child. Use those memories to inspire a painting or series of paintings.

Option 2, inspired by Donald Clegg:
Pay homage to a favorite artist by incorporating a reference to his or her work in your painting.

Option 3, inspired by Charles McVicker:
Include the image of an actual book or piece of writing in your painting and incorporate other objects to help tell the story of the piece.

"The rest of my painting relied on subjects that I might use anytime, chosen mainly for color harmony—the little dried mountain ash branch to echo Rembrandt's circles, and the curving top of the pear above, another echo. Although I'm more inspired by Rembrandt than Schama, if I hadn't

read Schama's narrative, I probably wouldn't have done the painting."

PUTTING A BOOK IN A PAINTING

"I'm a perceptual as opposed to a conceptual painter," Charles McVicker admits. "I use the world around me as my subject." Thus, he selects objects he cares about to put in his exquisitely painted still lifes. "And, although I'm not trying to convert anyone, I do read the Bible every day and I like the line from the Lord's Prayer, 'Give us this day our daily bread,' so I included both in my painting *Our Daily Bread* (on page 19).

McVicker paints in acrylic, and when we discuss how fast the paint dries and the problems with achieving soft edges on plane change accents, he laughs and says, "I'm really a finger painter," referring to the fact that he often softens an edge with his finger. He also uses a dry brush for this technique.

"I'm concerned with light and a theatrical presentation of my subject," he says. "You might call it a type of stage setting." For his dramatic renditions, he begins by coating a piece of bristol board with gesso for texture and tooth before he applies his acrylics. Within McVicker's dramatic presentations, characterized by extreme contrasts of light and dark, there are subtleties of value and nuance that can only be achieved by a masterful handling of one of the most eccentric mediums of all—acrylic.

◤CHALLENGE
⇛ *Play With a Title*

Create a symbolic or whimsical painting based on the title of a book that has special meaning for you. For example, I did the painting at right as a tribute to both the poet e.e. cummings and the late actor David Niven, whose autobiography *The Moon's a Balloon* changed my life. Niven's bravura, his abandonment to the adventure of life—he never seemed to worry about outcomes—and his indomitable spirit dominate his writings. In Niven's autobiography, something resonated so strongly with me that it gave me the courage to walk away from a bad marriage and strike out on my own without a cent! Niven epitomized for me a person who never stopped taking risks, who would never "Sleep his dreams," as e.e. cummings wrote in his poem "Anyone Lived in a Pretty How Town." This is a mandate I remind myself of daily—and certainly, as artists, a credo we all need to honor.

The three women in my painting, *The Moon's a Balloon* (mixed media and collage, 30" × 22"; 76cm × 56cm), appear often in my work and refer to various things. For example, they may symbolize the three graces or the three fates; the amalgamation of the mental, physical and

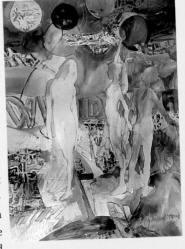

the spiritual; love, light and life; and the Freudian ego, id and superego.

I used a limited palette of Phthalo Green, Phthalo Blue and Napthol Crimson with a little Iridescent White and painted directly on the paper. At one point I spilled matte medium on the surface but used it to get texture and to glue collaged, stamped fragments of paper on the left and in the sky. In painting this work, at last I can express my gratitude to two writers whose words will stay with me always.

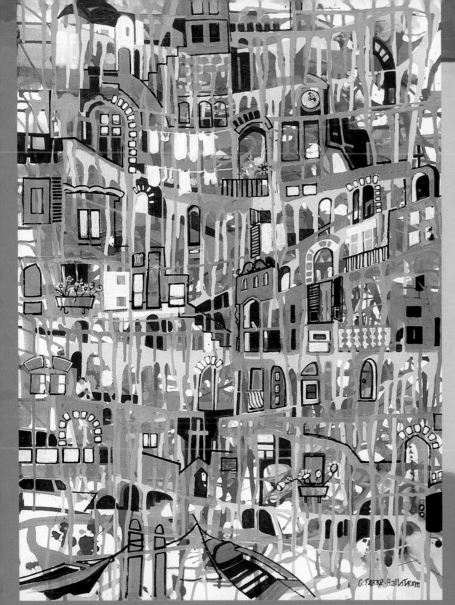

the **Creative Doodle**

> *"Painting has a life of its own.*
> *I try to let it come through."*
>
> ▬ JACKSON POLLOCK ▬

At whatever stage you are in your art, it's necessary, always, to improvise. Improvisational painting is the dance of the subconscious mind, the tango of creativity—twirling the more objective mind so fast that the pursed lips of criticism can't open until the spinning is over. And what, in the visual arts, is equivalent to dancing? Why,

⟨1⟩ DOODLING

Use a brush or a pencil to doodle. I began with images of some of my favorite symbols. I used a heart, an iris, letters of the alphabet—can you see what they spell?—my dog Scalawag's face as she slept by my side, my hand, a little unintelligible calligraphy (just for interest) and some lizards. First I drew the symbols with water-soluble Cretacolor pencils, then I traced over them with acrylics.

⟨2⟩ APPLYING WASHES

With Brera acrylics I added some light midtone washes in olive green, green-gold and Quinacridone Orange. When you add white or white gesso to a pigment, you create a veil.

⟨3⟩ DARKENING VALUES

To create more drama, I added some red-violet in a darker value. A shade occurs when you add black to a color, and a tint is a color mixed with white.

⟨4⟩ USING LINOLEUM STAMPS

Having previously cut designs into linoleum blocks, I stamped in various places. Most importantly, I added opaque grays made from green and red-violet mixed with white to augment and contrast with the transparent beginnings. The finished painting, *Confessions of a Dangerous Mind* (acrylic and water-soluble colored pencil, 30" × 22"; 76cm × 56cm), has passages of opacity and transparency.

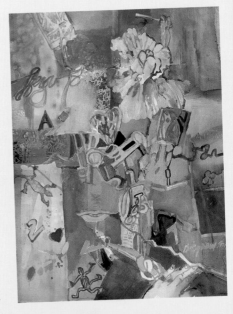

doodling, of course. Doodling is a somewhat subconscious activity and, as such, provides dramatic insights into our personalities and our psyches. How about doodling as a prelude to painting—a way of freeing our unconscious and tapping into our stores of creativity?

Maybe some of you are old enough to remember the zany lyrics from the old song "The Dipsy Doodle": "The things you say will come out in reverse/Like 'you love I' and 'me love you.'/That's the way the dipsy doodle works." Eureka! What a way to get from left brain to right brain: Doodle all the way.

USE A BRUSH

For the painting on the left on page 24, *Serendipity*, I began by making random marks with both watercolor and liquid watercolor, using different sized brushes on a sheet of hot-pressed paper. I drew onto a dry surface using an eyedropper filled with liquid watercolor. Sometimes I wet a brush and brushed into the liquid watercolor—making it a lighter value. Once the first layer had dried, I returned with other pigments and drew over the original lines—making new lines. Working transparently, wonderful color diffusions occurred. I used this method twice more before I completely covered the paper with marks (always letting each layer get bone-dry in between). After the last layer of paint had dried, I selected green to be my dominant color and added a small grid in a strategic place. Then I began making up shapes in the area of the focal point, where the calligraphy is most accentuated. The finished painting is a combination of various greens mixed with Ivory Black (for a shade) or with Titanium White or gesso (for a veil), and finally a mélange of grays made from mixing green with various reds.

DRIPPING AND POURING PAINT

To try this, take one pigment and drip it so it makes lines as opposed to shapes. You could use a dropper, syringe or oiler boiler. Before that application of paint has a chance to dry, pour another liquefied pigment into it, tilting the paper some more. Then add another pigment. You'll end up with a multitude of crisscrossed lines that you can study, then decide what to do with.

THE CREATIVE LESSON

What can you learn by doodling? By starting with nothing in mind, you can see how a nebulous beginning can foster a creative explosion. Moreover, the "doodle exercise" encourages you to experiment with contrasts of opaques versus transparents. As you doodle down the paper, you sharpen your compositional skills by having to make decisions about design. And from years of teaching I know something else: You'll love it!

THE DIVIDED BRAIN: GETTING THE RIGHT IN ⟨STEP WITH THE LEFT⟩

In 1981 Roger W. Sperry won a Nobel Prize in Physiology or Medicine for his research on the brain's hemispheres. He found that a fold in the cerebral cortex separates the two sides of the brain and that each hemisphere controls different modes of thinking. In simple terms, the left brain is verbal; the right brain, visual. For that reason, artists are, by definition, right-brain types. While one side of the brain may be dominant, the two sides should ideally work together. Any activity that requires you to switch from side to side, such as skating or dancing, puts the hemispheres in touch with one another. Doodle with your dominant hand and then with your nondominant one.

—*Maureen Bloomfield*

✍ DRAW OR POUR YOUR DOODLE ✍

Using a variety of brushes, draw lines and squiggles onto a piece of watercolor paper, and then, with veils, shades and a dominant color, pull the composition together. Another method: Drip and pour paint, tilting your paper until you have a substantial pattern of lines crisscrossing the paper. Then use color, veils and shades to bring the elements together. Pour with a dark pigment if you want the look of stained glass. You can also carve a stamp from a linoleum block, brush paint on the stamp and stamp areas of the painting.

For the picture on the right, I covered the paper with drips and lines of watercolor made by tilting the paper and doodling. After the paper had dried, I added a grid in the area of my focal point and began to paint—using green as my dominant color. For *The Jungle* (acrylic, 30" × 22"; 76cm × 56cm) on the left, Chica Brunsvold dripped paints, used a carved stamp and then defined her negative shapes by painting them with black gesso.

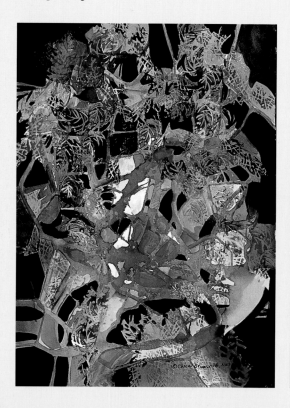

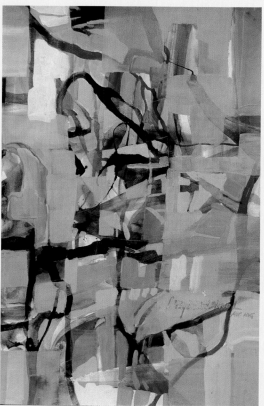

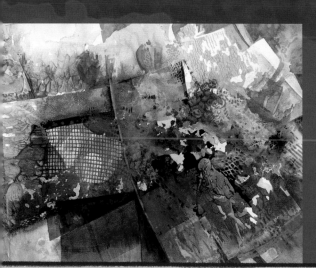

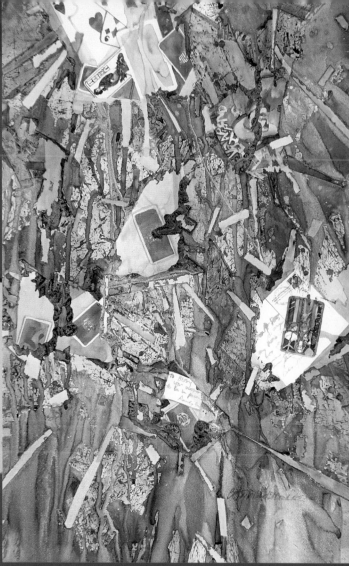

Two Ways to Pour

In *Arena* (watercolor on paper, 22"× 30"; 56cm × 76cm) above, Betty Braig created texture by pouring watercolor through filters. Another way is to tilt the paper and fling paint onto it. I started *Whatever Happened to Randolph Scott* (watercolor on watercolor board, 40" × 30"; 102cm × 76cm) at right by using wax paper and tape to save the white shapes. Then I chose an odd number of colors and mixed the paints with water. I like to have a predominance of either warm (as here) or cool colors. After starting with the lightest value, I moved on to darker values, ending with the darkest. Once I'd finished pouring, I removed the resists and painted the cards.

Pouring On Creativity

"We must still have chaos within us to be able to give birth to a dancing star."

═FRIEDRICH NIETZSCHE═

My ultimate creative bursts are flings—flings of paint! Perhaps my most creative series of paintings, *Postcards from the Edge*, involves pouring and flinging paint. From the wonderful process of pouring, I met my true creative self. Creativity is derived from a nonaction place, perhaps from reverie or daydreaming. Allowing yourself time to mull and loll about is essential, but after this initial stage, what next? To be creative, we must take

action and lose ourselves in the process of painting. I've found there's no better way to do that than to pour paint. When I pour paint, my outer self disappears into my creative self: I splash, spin, tilt and move in my own creative rhythms.

FIRST, LET GO AND ALLOW YOURSELF TO CREATE CHAOS

To be truly creative you must let go of preconceived notions. How can a cup already full receive more wine? When you let go of preconceived notions, you engage totally in the process of

↯CHALLENGE
⇒Pour Through Filters

A few years ago, Betty Braig took a workshop from Pat San Soucie, one of the Queens of Pouring, who taught her this method for pouring through filters. Here, Braig illustrates the exciting textural surface you can get from this method.

Materials You'll Need

- Any type of paper, such as hot-pressed, cold-pressed or BFK printmaking paper
- An assortment of absorbent filters, such as webbing, tissues, pieces of lace, rice paper, cheap paper napkins, paper towels, cheesecloth, gauze or coffee filters
- Plastic containers or baby food jars of watercolor or acrylic paints premixed with water. The paint should be very liquid, thinned considerably, in order to seep through the filters.
- A support for your paper
- Brushes, a watercolor palette and fresh mounds of paint
- A spray bottle, found in beauty supply stores, filled with water

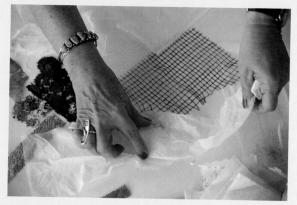

{1} ARRANGE YOUR MATERIALS
Place your filters on your paper, overlapping some of the filters. Spray water through the filters to wet them and hold them down on the paper.

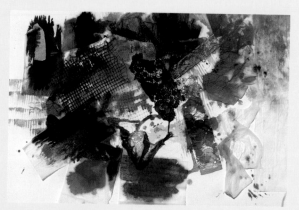

{4} CREATE TEXTURE
With the filters still in place, Braig poured red and yellow. On the left you can see the stamping marks she made with a piece of corrugated cardboard dipped in wet paint. While the paint is wet, you can lift the filters or drag them through the wet paint to create more texture.

painting, without worrying about the product. When you are at your most creative, you are fully immersed in the artistic process, establishing a direct link to our creative self, which allows us to create with abandon.

Some wag wrote, "Better a creative mess than a stagnant neatness." For years this quotation has been my motto. Creativity often comes out of chaos. It's after this initial creative departure—after you create chaos—that the discerning artist steps in to pull everything together. There's no better or easier way to create that chaos than to pour paint.

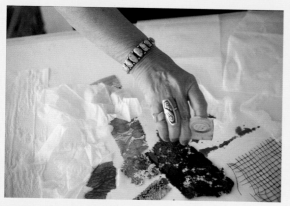

{2} POUR PURPLE

Pour your first color over the paper at random, observing how the materials soak up the paint. She uses a small plastic spray container, but you can experiment with any container.

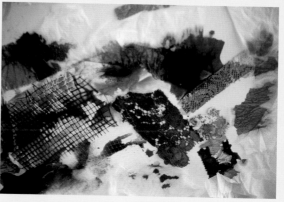

{3} POUR GREEN AND BLUE

Pour more of your colors. Here, Braig poured green, Prussian Blue and purple.

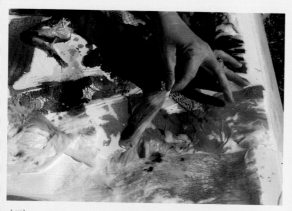

{5} CHECK YOUR PROGRESS

Lift a corner of one of the filters to see how the pour is progressing.

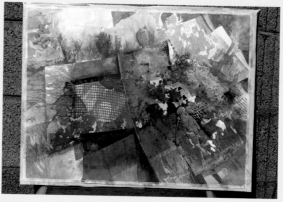

{6} REMOVE THE FILTERS

When Braig removed the filters, a beautiful pattern was revealed. The challenge then was to make this into a completed painting by combining drawing and more collage. Do whatever the painting seems to need.

Pour paint and let go. Forget about the outcome. Become fully engaged in the process, allowing the infinite possibilities of the creative act to come forth. Your artistic spirit will soar and your creativity with it.

My adventures in pouring paint came about because of a commission I accepted years ago. Lots of artists warn, "You can't be creative when you paint commissions." Bull jive! Had I listened to that advice when the wife of the World Bridge Champion asked me to paint a commemorative painting, I would have lost a great opportunity. As it happened, that commission began a series of poured paintings that changed my life. Remember: You have to listen to your instincts. Intuition as a creative force is infallible.

BEGIN WITH A SUBJECT OR INTENTION
Just as true content comes from deep within, selecting the proper subject for your pourings is paramount. You may well ask, "Why do we have to select our subject? Isn't pouring paint a way to find a subject?" I think that it's better to pour with a subject in mind. When I accepted the challenge to paint the commemorative painting, I started to think about my own experience of growing up in a family of card sharks who played everything from bridge to cribbage with battles that have been compared to Waterloo. When presented with this challenging commission, all I had to do was reach deep within and resurrect those emotions connected to cards. So my advice is to pour with your own subject (and this can be a feeling) in mind. I have made paintings with all sorts of subjects, and I've found that it's possible to make any of them work. I have painted, for example, still lifes, florals, figures, masks and even landscapes by starting with a pour of paint. If you don't have or don't want to have a subject in mind, however, don't give up on the idea of pouring. You can create a dramatic abstract or expressive painting from pours of paint.

TWO DISTINCT WAYS TO POUR PAINT
There are as many ways to pour paint as there are artists who pour. In her demonstration on pages 26 and 27, you saw how Betty Braig poured through materials like filters or stencils to get textures; she then developed those patterns into a finished painting. I, on the other hand, masked with materials like tape and wax paper, to save interesting white shapes, from which I developed my subjects. With my technique, you can also use liquid frisket, frisket paper, collage or rice paper as a resist. If you use rice paper, you can collage that paper into the final painting.

GIVE UP CONTROL
When you pour paint, you give up control to a force that exists outside yourself and yet acts in conjunction with yourself. You allow watercolor or another water-based medium to show its personality and then merge with your own. I often tell people, "I love watermedia because it's eccentric and so am I." Pouring paint may be scary at first, but try it! It's a ride on the artistic roller coaster that, believe me, you'll never forget.

◀CHALLENGE

⇒*Pour and Fling*

Materials You'll Need

- ◆ Watercolor paper or board
- ◆ Five to seven paints mixed with water in separate containers. If you want intense color, use less water. Here I used these MaimeriBlu watercolors: Golden Lake, Garnet Lake, Primary Blue, Sepia and Orange Lake.
- ◆ Masking materials, such as drafting or artist's tape, frisket, wax paper and collage paper. Make sure the tape sticks tight in the places you don't want the paint to run, though this can create interesting textures.

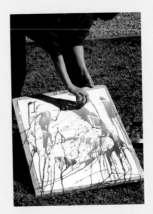

{1} FLING PAINT

After I mask out some interesting shapes with tape and wax paper, I begin by sloshing on Golden Lake. I heave, slosh and pour the paint, sometimes lifting the paper as I pour. You can tilt your paper or lay it flat. Sometimes I even put the board completely upright against a tree or wall and toss paint from a distance for greater impact. And, oh, do it in your yard! That's a must!

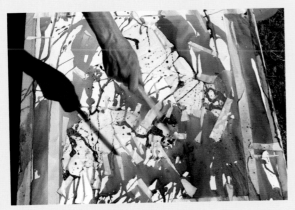

{2} PLAY WITH THE FLING

Aid and abet the wonderful diffusions as you manipulate the color with a brush.

{3} REMOVE THE RESISTS

After the painting dried, I removed the tape and wax paper, painted the symbols, and stood back to assess my design. My final touch: I added layering, more color, and a veil with Naples Yellow over the bottom of the painting to create more ambiguity and decided—I like this! The final result is *Ode to Grandfather Raven* (watercolor, 30" × 22"; 76cm × 56cm).

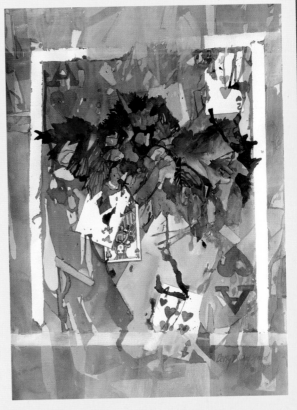

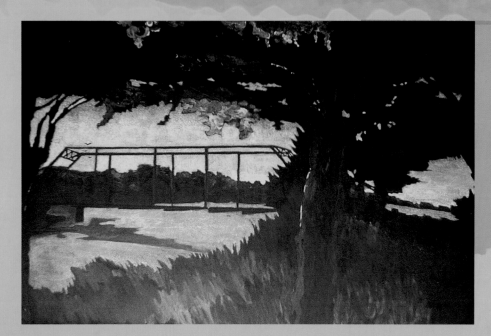

a **Walk** into **Creativity**

> *"As we draw closer to Nature, we simultaneously draw closer to ourselves."*
>
> ⟞ PETER LONDON ⟝

About seven years ago I started teaching at the Shemer Art Center in Phoenix, combining a curriculum of painting and writing. I hoped strong and unexpected images would appear in the students' writing, enabling them to draw from the repositories of material inside themselves—treasuries of unlimited ideas and imagery. Unlocking that mysterious barricade that often prevents us from using our own original thoughts and images would make the content of our painting stronger, more insightful. Then we as artists would come closer to fulfilling one of the purposes of being an artist—perhaps the most important purpose—expressing our world, whether it is the outer or the inner one.

There are no shortcuts to this process. We all, I believe, are more equipped to compose our art if we know the basics and understand our materials. It is, however, the journey beyond technical ability that separates Sunday painters from serious artists. As Joseph Campbell, the renowned expert in comparative mythology, said, "At the end of the journey, we realize that the end is the journey."

A SILENT WALK TO START
In a workshop in Aurora, Nebraska, I asked my delightful, energetic class to explore the process

❧ WORKSHOP ARTISTS TAKE A WALK ❧

After walking silently in nature for ten minutes, then writing for another ten minutes about what they experienced outside, my workshop students in Aurora, Nebraska, created these paintings.

Charl Ann Mitchell

"As I walk outside, I feel gales of wind, the wind of God's spirit blowing away my fears. I am floating with the winds of the spirit. I see the ripples of water, circles getting larger and larger. I see a leaf blowing across the lake to the other shore. Are we but leaves floating to a distant shore? The water beneath me carries me—weightless as a leaf upon the waters. I am freed of clutter, cares, worries, fears. I feel centered, light and purified." Mitchell then painted *Be Still and Know That I Am* (acrylic on paper, 22" × 30"; 56cm × 76cm).

Carol Schinkel

Following the silent walk, Schinkel contemplated the power of words to hurt and to heal. She called the resulting painting *Watch Your Words* (acrylic on paper, 30" × 22"; 76cm × 56cm).

Jene Rasher

"As I walked outside, I experienced goose bumps I don't usually feel. This was a different journey, one I could slow down to and thus notice the green grass and the tiny dandelions waiting for the sun. Moving forward, I came upon cotton seeds left from last fall's weed pods. They had not yet decomposed to add food to the soil. In a similar way, the leaves, stems and other natural residue lay waiting to accomplish their purpose in nature's cycle. I wanted to move like the wind, softly waving in the tall gold grass. Oh, to be here each morning to view nature so deeply." Rasher then painted *Cycles of Life* (acrylic, modeling paste and gesso on paper, 30" × 22"; 76m × 56cm).

TO BE SILENT IS TO BE
❧ FREE OF DESIRE ❧

"The 20th century is, among other things, the Age of Noise," proclaimed Aldous Huxley in 1946. Now, we're never out of reach of the radio, the TV or the cell phone. And what we're hearing, for the most part, is a demand that we buy something. Huxley indicts what was, even in 1946, an instant and throwaway culture by excoriating the industry of advertising: "Spoken or printed, broadcast over the ether or on wood-pulp, all advertising copy has but one purpose—to prevent the will from ever achieving silence. Desirelessness is the condition of deliverance and illumination. The condition of an expanding and technologically progressive system of mass production is universal craving. Advertising is the organized effort to extend and intensify the workings of that force, which (as all the saints and teachers of all the higher religions have always taught) is the principal cause of suffering and wrong-doing and the greatest obstacle between the human soul and its Divine Ground."

of writing and painting. Their enthusiasm knew no bounds, and soon we were outside, walking silently. Early April in Nebraska was so different from early April in Scottsdale, Arizona, where I live. I gloried in the differences: the crisp, cold air and the faded remnants of winter, which would soon be gone, and the thick, dark green trees that contrasted with the muted neutrals surrounding the lake. For ten or fifteen minutes, without speaking, we each wandered around outside, some of us stopping, some of us sitting, each lost in her own thoughts. When we came back inside, we wrote about our experiences. The writing was miraculous.

Now, don't get scared. You don't have to be D. H.

⬅ CHALLENGE
⇒ Walk in Nature

Abstract Approach From a Walk

I gave my students and myself the following assignment: to paint in grays and blacks, a study in values. In addition, we could use a number that was important to us in the composition. After drawing my design, I began to experiment with my monochromatic palette using different values and hues of black and gray—leaving a lot of white shapes in my composition for contrast. I taped off geometric areas to suggest the refractions of light and shapes I observed in the window. I began painting in light values, stamping occasionally with a design I'd carved on a linoleum block. I built up the values slowly, while allowing each layer to dry. My grays were a mixture of Holbein's Grey of Grey and MaimeriBlu's Ivory Black and Carbon Black. I mixed Daniel Smith Antique Gold with the blacks to stamp. The number 444 has special meaning to me, and I added that element to the painting. As a final touch, I added a glaze of a little MaimeriBlu Golden Lake and Avignon Orange to the center of interest in *Silent Walkers* (watercolor on cold-pressed paper, 30" × 22"; 51cm × 56cm), which was inspired by the following text:

"When I walked outside the Shemer Art Center in Arizona, I immediately looked to my left and saw the bright terrazzo roof of our building blasted by sunlight. A Dioxazine Purple shadow, with perhaps a little Medium Magenta thrown in, sliced the yellow-white building into sharp angles—but then I looked to the right of the shadow, and there in the window, I saw us—ghosts reflected in the glass, moving silently, as if in slow-motion, on our quiescent journey. As I looked, I saw the myriad shapes inside the

Lawrence, John Grisham or Barbara Kingsolver to do this exercise. But! You do have to be silent for the whole walk. I suggest you get a small group of artists together at some picturesque place. You could go to a park, an art center that has a sculpture garden or

window, cutting through our shapes, breaking up the apparition into a geometric puzzle. We moved through this mathematical mystery as if in a dream."

Representational Approach From a Walk
This painting is a more literal translation of a meditative walk. Using layers of transparent acrylic paint and letting each layer dry in between, I built up the surface gradually, until the tinted layers overpowered the black. Then I began defining the scene with opaques and more transparents in *Aurora, Nebraska: Where There Is No Home Depot* (acrylic on black-gessoed illustration board, 20" × 30"; 56cm × 76cm).

someone's backyard. Appoint someone as the leader—the person who will not let you talk—and simply walk outside. And I cannot emphasize enough the importance of not talking. Some people will want to loiter at a site; some people will walk the entire time. It's an individual decision, as is what you write when you return.

a **Line** to **Creativity**

*"In spite of everything, I shall rise again.
I will take up my pencil, which I have
forsaken in my discouragement, and
I will go on with my drawing."*

⇒VINCENT VAN GOGH⇐

What can squiggle, twist, curve or go straight? What can be thick, thin, nervous or faint? What does not exist in nature, but can often reveal the most expressive characteristic of our work? The answer? Line, beautiful line, a design element that sometimes goes unnoticed or is often underestimated. It is impossible to think of Vincent van Gogh, Raoul Dufy, Wassily Kandinsky, Paul Klee and Piet Mondrian without visualizing their creative and expressive use of line.

Think of van Gogh. His line exudes aggressiveness, sensuality, sensitivity and boundless energy.

Combine Line Techniques

In the far background of *Mud Island* (watercolor and gouache on board, 22" × 30" ; 56cm × 76cm), Jason Williamson's extraordinary line is a combination of a variety of grays, from a medium value to black, executed with a very fine brush. On the far side of the boat, he floated in light washes of gray-greens and muted pinks, which served as a structural underpainting for the darker strokes of watercolor he would later paint to indicate weeds. After this area dried, he added more weed-like brushstrokes in light, opaque Naples Yellow watercolor. To suggest weeds receding in the distance and to intimate an aerial perspective, Williamson darkened the initial opaque washes by adding a tint of gray. He wiped out grasslike reeds with a wet brush, which he was able to do because he was painting on a board with a slick, plate finish. The solemn mood established by the monochromatic ambience of his palette—dark and gray—evokes the stillness and silence of a marshland uninhabited by man. Heightening this effect is his beautiful, elegant use of line.

Contrast Positive and Negative Lines

Here, Jason Williamson poured Alizarin Crimson, Lamp Black and Ultramarine Blue on hot-pressed board. After the painting had dried, Williamson misted the surface with an airbrush to prepare it for the scratch-out process. He scratched out the finest, most delicate white lines using the sharp tip of a craft knife. Then he augmented the linear marks by making lines with white opaque paint put into a ruling pen. He adopted a free and spirited way of using the pen as though it were a brush. Notice that there are two personalities in the lines: the subtle lines made with the craft knife, enhanced by the stronger lines made with the ruling pen. This contrast creates depth and excitement in *Transformation* (watercolor and ink on board, 22" × 30"; 56cm × 76cm).

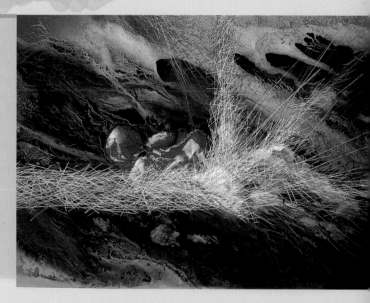

Not only are his paintings characterized by bold, interpretive, brilliant color, but it is his color, combined with his powerful, gestural line, that makes his work distinct.

On occasion, well-known Arizona painter Jason Williamson uses line as a tool. "I use line," he explains, "when the painting itself declares that line is what is needed. There is no such thing as line in reality. It is simply the marked reduction of a form to a simple shape, and all line has a personality of its own." In *Mud Island* on page 34, for example, Williamson makes use of a variety of linear marks executed with a very fine brush. His monochromatic palette of grays and elegant, expressive line work in tandem to evoke the moody atmosphere of a marshland uninhabited by man.

As you look at the images I have assembled on the next few pages, notice the unique qualities of each artist's approach to line. You, too, can develop your own individual linear mark, one that is yours and yours alone. Try one or all these approaches to line, and then, perhaps, invent some of your own.

Combination Dry and Wet Media

Blend some areas and reinforce others with ink and line. Methodical crosshatching with watercolor pencils, sometimes layering one color over a different one, produces the beautiful color tones in John J. Yiannias' *Paris, Certainement!* (watercolor pencils and ink on Clayboard, 19" × 14"; 48cm × 36cm). Having completed the exquisite drawing with watercolor pencils, Yiannias wet the drawing with a fine brush, carefully blending all his pigments together. Then he used colored ink to carefully match his blendings, filling in any tiny, uncolored spaces that may have been left on the surface. Most of the linear appearance disappeared once the artist wet the paper. Yiannias also likes to incise lines into the board itself.

Describe Shape With Bold Line and Color

In this charming minimalist painting, reminiscent of Mondrian, Laurie Rothrock explores the relationship between bold, flat color and line. She translated a memorable dining experience into a colorful and whimsical painting, employing a bold, black line to make her statement in *Dinner at Gloria's* (transparent watercolor on paper, 22" × 30"; 56cm × 76cm).

Use Line as a Decoration or Pattern

A pattern of lines weaves through this painting as if it were a tapestry. Bold, flat and simple shapes, decorated with a variety of lines placed in a shallow space, occupy a plane in front of a brilliant blue background that is also decorated with line. All the values are kept close as a means to suggest the closeness of the figures in Rothrock's *Park Bench Ponderers* (acrylic on paper, 22" × 30"; 56cm × 76cm).

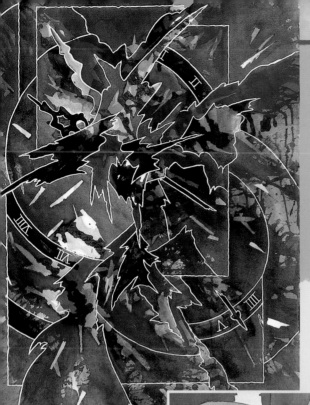

Masked Lines

Jo Toye began this dynamic painting by drawing her design with a pen dipped repeatedly in frisket. Be forewarned, however: This is a time-consuming effort because you must make sure you keep your pen or nib unclogged. Once the frisket had dried, Toye mixed fluid acrylics in separate containers, adding a bit of water to make them more liquid. She used Phthalo Turquoise, Quinacridone Crimson and Quinacridone Gold. She masked out some shapes with drafting tape and others with frisket. After this step had dried, she removed the frisket and adjusted the color by glazing. *Split Second* (acrylic on paper, 30" × 22"; 76cm × 56cm).

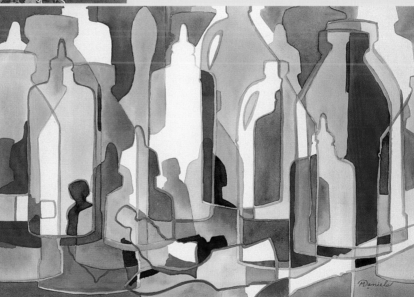

Create Abstract Shapes Over a Contour Drawing

Known for her strong designs and her beautifully composed paintings, usually done with a limited palette, Mickey Daniels started *The Assemblage* (watercolor and acrylic on paper, 22" × 30"; 56cm × 76cm) with a contour drawing. She cut a template for every object in her painting. Then she drew abstract shapes on the templates and cut various sizes and shapes out of the middle of each larger form. She overlapped the templates on watercolor paper to create a pleasing composition and outlined the silhouette templates with acrylic paint, then completed the painting with watercolor. Daniels says she enjoys doing this exercise because the results are always a surprise.

Paint Over an Ink Drawing

Naomi Brotherton started *Carnival* (watercolor and ink on paper, 22" × 30"; 56cm × 76cm) by drawing her design with a goose quill pen she made herself and waterproof (very important!) black India ink. She also wet parts of the paper before painting in order to achieve softer effects. She made a variety of gestural lines of different widths. "Drawing with a goose quill is exciting," she explains, "as you never know what it will do." You can twist and turn the quill and get a variety of results that will give you an electrifying drawing. After letting her drawing dry overnight (ink takes a long time to dry), Brotherton painted a splashy wet-into-wet application of watercolor.

Draw Over an Underpainting

Painting wet-into-wet, I put down an underpainting, remaining mindful of each brushstroke. I didn't develop the underpainting; I simply let it dry. I then drew my Japanese doll, "Ichiban #1," onto the brightly colored surface using Prismacolor pencils. Then I carved a simplified stamp of the doll to use as both a linear and textural motif. I used MaimeriBlu watercolors and gouache to draw the lines around the doll and to paint the stamp, adding a bit of Daniel Smith Interference Red watercolor to the stamp to give it more body. When I stamped, I also used, in addition to the Daniel Smith Interference Colors, MaimeriBlu's Naples Yellow Reddish or Holbein's Grey of Grey—both opaque watercolors—to give the paint more body. Everything in the drawing except the doll was an immediate and intuitive response to the painting as I designed it. After I had finished most of the painting, I looked at it and added gouache and touches of Prismacolor in places that needed emphasizing or changing in *Ichiban #1* (mixed watermedia on paper, 30" × 22"; 76cm × 56cm).

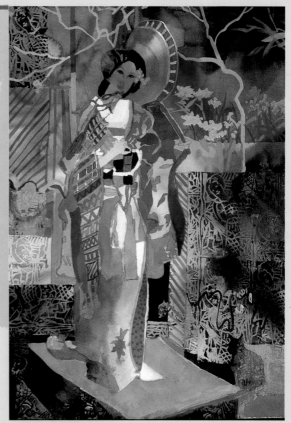

Layer Drawn and Painted Lines

Daniels used two drawings of water lilies for this painting. She traced one drawing onto the paper and reinforced it with an acrylic line. After that dried, she used pencil to trace another drawing over the first, placing it to make interesting shapes. Then she finished *Summer Sonata* (acrylic and watercolor on paper, 22" × 30"; 56cm × 76cm) with watercolor.

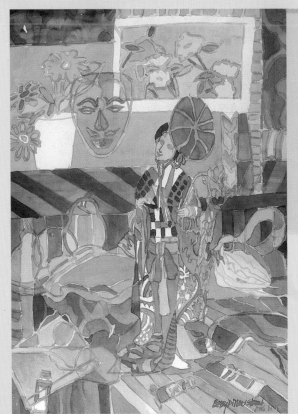

Draw With a Brush

Drawing a line in Verzino Violet watercolor with my kolinsky sable brush, I drew a still life of objects. I drew it almost like an X-ray, overlapping objects so you can see through a lot of them. After the line dried, I made sure I had an interesting kaleidoscope of various shapes in my composition. The more, the merrier! I decided on a limited color scheme of Golden Lake, Green Blue and Verzino Violet MaimeriBlu watercolors and then started painting in my shapes. Every time I came to a line, I changed the color or value. Then I pulled the composition for *The Pearl of the Orient #4* (acrylic on paper, 30" × 22"; 76cm × 56cm) together by glazing and darkening areas and adding linear decoration where needed.

⬳CHALLENGE

⇒*Cast Your Own Line*

Henri Matisse said, "Drawing is taking a line for a walk." Take your next painting on a "line walk." Create a painting using line as the dominant motif.

Jazz Up Your Creativity

"Painting is a bit like playing jazz. When you play jazz, you're playing your whole life— all your experiences, both good and bad."

⬗ HERB ALPERT ⬗

Is it a surprise that Herb Alpert is a creative magician in more than one avenue? No. Just as a passion for one of the creative arts often leads us into the exploration of another, the umbilical connection between music and painting is direct, concrete, irrefutable. Writer and art connoisseur Calvin Goodman expounds: "Herb Alpert's use of rhythm, chromatics, color relations and structure reveals a strong similarity between music and art." Undeniably, that creative spark can go wherever

Courting a Musical Muse

In 2003, the Watercolor Art Society of Houston presented Herb Alpert with the Distinguished Award for Outstanding Commitment to the Arts. In *House of Blue Lights* (acrylic on canvas, 44" × 58"; 112cm × 147cm), shapes resembling musical instruments mingle with more amorphous forms.

it's directed, and in Alpert's paintings, his explorations are fueled by his lifelong passion for, practice of and dedication to music.

As Wassily Kandinsky wrote, "Color is the keyboard, the eyes are the harmonies, the soul is the piano with many strings." Although Kandinsky was the first modernist to illustrate that concept visually, throughout the history of art there has been an obvious correlation between music and painting, as well as between architecture and literature. In *Dreaming with Open Eyes*, Michael Tucker writes, "Jazz musicians are the shamans of the modern culture—shamans because they seem to tap into the subconscious of all the cultures." So, what about Alpert, artist/shaman/jazz musician? How did he make the transition? What can we learn from his explorations? I collected a list from his musings and reflections—gleaned from our conversations— insightful remarks guaranteed to push us farther along our creative path as Alpert explains how he nurtures and develops his own.

LEARN FROM AND ABOUT OTHER ARTISTS

In the mid 1960s, while touring Europe with the Tijuana Brass, Alpert began visiting major museums. He relates: "When I got to the modern art section of museums, I gravitated toward contemporary pieces because they reminded me of a Charlie Parker solo. That kind of liberation and

Self-Portrait of the Artist as an Eye

Improvisational and energetic brushwork activates the surface of *Point of View* (Iris print on paper, 14" × 11"; 36cm × 28cm). Notice the contrast between linear strokes—like stripes that commingle with flatter, smoother passages—and the signature repetition of the ovoid form.

improvisation gives me the freedom and the ability to go wherever I wish. You have to be receptive and open to an artist at a particular time, as sometimes you aren't ready or able to get that particular message." He laughs a deep-bellied laugh and says, "Just because I ain't receivin' don't mean you ain't sendin.'"

We speak of the relevance of Duke Ellington's famous quotation: "It don't mean a thing, if it ain't got that swing." Addressing this idea, he recalls, "Before I started experiencing the art 'a-has,' I

Triplet Beat
Shapes resembling musical instruments sally through the composition, implying syncopated rhythms in *Cha-Cha-Cha* (acrylic on canvas, 48" × 36"; 122cm × 91cm).

of what I'm doing when I'm doing it. I never know what will happen, but once I start, it's as if something else takes over and I'm improvising with color and shape as I do with music. I would tell you to put your life energy onto the canvas or paper and look for the same thing in your painting that you would look for in music—harmony and transpositions." Transpositions in music refer to changing into another key. In painting, transposing would refer to using different color harmonies or a different format with the same subject in order to create a different but related visual sequence.

Echoing other artists, Alpert confesses that he is often mystified by what he has created: "After my recent exhibition was hung, I remember walking around looking at my work and stopping in front of some pieces and saying how in the heck did I get that texture or that color or that depth? Sometimes it's like something completely out of my control." Artist Audrey Flack describes "the act of disappearing" another way: "When you paint, everyone in your life is standing in the room with you—all your teachers, friends and family—and then, one by one, they walk out, and if you are really painting, you walk out."

thought Rembrandt was dark and gloomy. What was all the hullabaloo about this painter? I asked myself. Then Tijuana Brass went to Holland and I saw the actual work and got goose bumps! And, once you get on that wavelength, it opens you up to other wavelengths, other artists." Other influences for Alpert are Henry Moore, Diego Rivera and Rufino Tamayo, especially Tamayo's colors.

DISAPPEAR INTO YOUR WORK

In *Free Play: Improvisation in Life and Art*, Stephen Nachmanovitch writes, "For art to appear, we have to disappear. … Mind and sense are arrested for a moment, fully in the experience. Attention and intention fuse." Alpert relates the same idea: "When I paint or sculpt, I'm not sure how conscious I am

LEARN AND THEN FORGET THE BASICS

"To me, painting is very much like jazz," muses Alpert. "You get your palette, or your scales and your notes, and what you have to know, so you can forget that and let it fly." Alpert's observation is both the essence and at the core of all improvisation and creativity. Learn the rules, and then break

them in your own expressive way. Alpert continues, "You work with various colors for a while and with tricks you learn along the way—all the things that work for you. Then you can forget them, and, for sure, something new will emerge from that."

TRUST YOUR FEELINGS AND INSTINCTS

"When it feels right, I stop, and when it doesn't, my body tells me. That's what happens when I make music! I pursue that 'relaxed' state that can only come when 'everything feels right,'" Alpert explains. Again, he expresses a tried-and-true artistic tenet. As the famed artist Robert E. Wood always said, "Trust your feelings."

APPROACH EACH PAINTING AS IF YOU WERE STARTING FROM SCRATCH

"I feel as if I start from scratch every time I pick up a brush, even though I'm using some of the tools I've learned from past experiences as a kick-off point," Alpert tells me. "I take chances with what I see evolving on the canvas or paper." His impromptu meanderings in color and line allow for serendipity. The chance occurrence then can mingle with the repository of images and techniques that he has stored up in order to produce something new. And, after all, doesn't the word *creative* imply bringing forth all those things that haven't been brought forth before?

APPROACH THE PROCESS WITH PASSION AND FORGET ABOUT THE PRODUCT

"Once you get conscious of what other people will think about what you are doing, you get out of the state of love you should experience when you are doing it," says Alpert. The important dialogue is the one the artist has with pthe ainting because, as Alpert is telling us, once we begin to worry about whether someone will purchase our painting, or like it, creativity takes a fast hike. Its flight is compa-

THE DYNAMICS ∽ OF CONTRAST ∽

Herb Alpert's paintings, such as *Bebop* (acrylic on canvas, 72" × 108"; 183cm × 274cm), are consummate examples of the successful uses of contrast. "In music," he says, "it's called dynamics." The tactility of the surface is an important consideration. Surfaces abound with swirling masses of granular applications, which he achieves using acrylic polymer media, so smooth passages glide into textural ones.

Often he begins a work by applying wood shavings, modeling paste, pumice, black lava and other acrylic media to produce plasticity of surface for the color and shapes that are to follow. Sometimes Alpert finishes an entire painting with the same large brush. His brushwork is kinetic, again an aesthetic link with music, and his textural sensibilities are akin to the different timbres in music.

rable to an Arizona roadrunner who shoots out of sight, leaving a residue of disparate creative dust falling to the ground.

BE AUTHENTIC TO WHO YOU ARE

By being authentic, you honor "who you are." Although essentially self-taught as an artist, Alpert's sophistication and inherent knowledge

Rhythm is Repetition
In *Seashell* (acrylic on canvas, 48" × 72"; 122cm × 183cm), Alpert uses a curvilinear, calligraphic line along with expressive shapes to suggest the luminous movement of tides and other natural cycles.

of form and structure, of harmonics, orchestration and innovation, have transmuted his lifetime of musical experiences into his art. Instead of a trumpet, his brush records his sounds not in the air, but onto canvas or paper, and his harmonics are the coloratura of pigment. "When your life energy flows onto that canvas unencumbered by the thoughts and desires of others," he advises, "your true self will emerge."

An example of this process is *Seashell* above, in which there is the sense of both the familiar and the unfamiliar combined: yin and yang, organic and inorganic. There is both the feeling of a musical instrument and the sound of the ocean implicit in the image.

Ask yourself, "How do I direct my energy? What are my life experiences? More importantly, how can I express them through my art?"

WORK QUICKLY AND FREELY

When Alpert paints, he starts with familiar shapes and allows others to emerge. Often he works with one big brush on an entire painting. His painterly gestures are those of a dancer in rhythm with his music, fluid, grandiose and energetic. Often he employs sgraffito, a technique of scratching back through the paint or texture to make a mark.

Sometimes colors float in his mind, and sometimes they, too, seem to appear out of nowhere. He reflects, "Sometimes they are colors and shapes I have retained or logged ahead, and other times they just appear." He chuckles. "It's seductive that as an artist you discover something new all the time. Some days I feel as if I have magic dust on me, and other days I feel as if I could hang it up."

The big connection between music and sculpting and painting is this: that it is all essentially the same discipline. That's why Alpert came up with the title *Music for Your Eyes* for a catalog of his work. As he explains, "I actually listen to the painting as I work, and when I do, it always tells me where to go. Music and art programs in our school systems are essential because the kids growing up today aren't able to appreciate anything but the music and art that they are being fed at that moment." He continues, "As a society, we are measured by what we create, not what we destroy"—a haunting, resonating note to end on, but for Alpert, artist-musician extraordinaire, the beat will always go on.

CHALLENGE

Let Music Inspire You

I grew up in a family in which you were put up for adoption if you couldn't play the piano and sing. Before we were of kindergarten age, my sister, my cousin and I were plunked down in front of the radio to listen to the opera of the week. At the time I would rather have been hanging upside down from a tree, but now I realize how extraordinarily blessed I was to have had the influence of such a family.

Look at a book of paintings by Claude Monet as you listen to music by Claude Debussy or Maurice Ravel. Or,

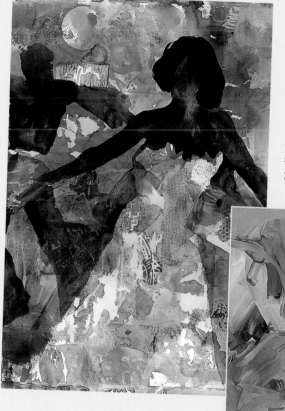

put on Herb Alpert while you look at the paintings in this section.

Your creative challenge is to put on one of your favorite pieces of music, then let it all hang out. Try to mimic the rhythms of the music with your paintbrush. Acrylic may work better than watercolor with this exercise—or add opaque pigments like gouache if you are using watercolor. Think about Alpert's considerations, and disappear into your work. Trust your instincts about color, and don't stop to critique your work until you've gotten that first burst of creative energy out. Or, create an underpainting while listening to your favorite music and then, after it dries, superimpose abstract or realistic shapes over your painting.

I selected a simple palette of red-orange, green and purple, having some Titanium White on the side to make opaques. Mixing a lot of matte medium with my paint, I began to merge into the rhythm of the music of Alpert with my brushstrokes. When the music stopped, I stopped. The result is *The Look of Love* (acrylic on paper, 30" × 22"; 76cm × 56cm) below.

For *Lieber Tango* (watercolor and acrylic, 30" × 22"; 76cm × 56cm) far left, I poured an underpainting and added texture with stampings and imprints. Over this underpainting I quickly painted in the dark silhouettes of dancing figures while listening to "Lieber Tango," played by Alpert and the Tijuana Brass.

Inside the Creative Rectangle

"The position of the artist is humble.
Essentially he is a channel."

⟩ PIET MONDRIAN ⟨

In the same way that a day in an art museum can provide fuel for an entire year of making art, every experience looking at something beautiful or new can be a starting point for a creative jaunt that will perhaps provide a breakthrough. The quest in this challenge is to look at Piet Mondrian. To some viewers, Mondrian may seem quintes-

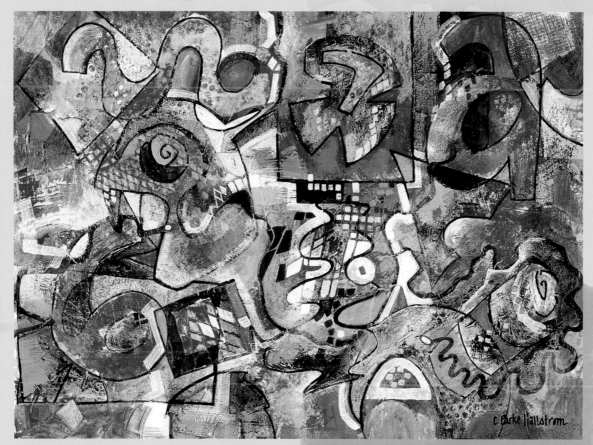

C. Parke Hallstrom

Looking at Mondrian and Starting Afresh

C. Parke-Hallstrom took a serious look at Mondrian's works and integrated his approach into her own in *Electric Dance* (acrylic on paper, 22" × 30"; 56cm × 76cm). Curvilinear forms in reds, yellows and oranges dominate the painting, and there is only a smidgen of black in the whole thing. "I lost myself" is how Parke-Hallstrom describes her process. Losing ourselves is exactly what happens when we are in flow. Inevitably, we begin to "do our own thing."

sentially enigmatic. That's because he is! The challenge is not to copy Mondrian, but to look at his signature works and from that experience create a painting. Read about him if you have time. At the very least, looking at Mondrian's work will be challenging, stimulating and thought provoking. "How many ways can you decorate a rectangle?" skeptics might ask. "Well," you might answer, "you could start by looking at Mondrian."

It is late March 2003, and I am in El Dorado, Arkansas, teaching a workshop at the South Arkansas Arts Center. The redbud is blooming, and the Bradford pear trees are laden with lush white blossoms. The delicate smell of wisteria says, "Spring is here." I have fallen in love with a guy named Jack Merkle. Never mind that he is a golden retriever,

and that his owners, my friends Sarah and Bob Merkle, won't let us elope.

And to top it off, I have an exceptional class– open, questioning, ready for creative challenges. They are eager to jump out of their safe box and sail into the unknown. "Let's try this," I say. "We can't wait," they answer. I had just given an experiment

A CREATIVE
❧ TRANSFORMATION ❧

Rhonda Hicks enlarged a photograph from her own files on a high-resolution color photocopier; she then made a black-and-white photocopy. Next she drew shapes and lines on the photocopy with a black marker. Notice that in the final painting she changed the orientation from horizontal to vertical. When shapes change, it is often because something in you is telling them to—you're "listening to your painting." Once Hicks transferred her design to watercolor paper, she added bold, vibrant colors in *Tropical Porch* (watercolor and ink, 30" × 22"; 76cm × 56cm).

in the manner of Mondrian to my private Master Class in Scottsdale, Arizona, and the exciting paintings generated there made me want to try it again with the Arkansas group, so we simply looked at the more mature geometric works of Mondrian and then painted.

WHO IS MONDRIAN?

As John Milner wrote of the artist in *Mondrian*, "He was a man of great simplicity." Everything in Mondrian's life suggested sparseness, austerity and clarity. His only exuberance, according to Milner, was an attraction to the tango and the gramophone. Mondrian was also a student of the famous metaphysician Madame Blavatsky, who launched

the Theosophical Movement that introduced Eastern ideas of karma and reincarnation to the West. Throughout his life, Mondrian remained interested in metaphysics, particularly the nature of the universe and his role in it. Mondrian's experiences took him from New York to Paris, back to Holland, then back to New York, where he met and belonged to influential painting groups of the time. Throughout his life— he died at age seventy-two of pneumonia—he never lost his austerity. In his studio, displayed prominently on the wall, were colored cards that he constantly rearranged to give him ideas for his paintings. In keeping with his somewhat sober personality, he reduced his realities to a series of cubes, rectangles, squares and other geometric

combinations. Before you take up this challenge, you may have some questions about "copying," so here's my answer.

THE GREAT TRADITION: COPYING MASTERS

Throughout the history of art, artists have borrowed motifs, designs and gestures from other artists. It was considered de rigueur for art students in many places, especially L'École des Beaux-Arts, to copy a master. I, too, when studying Maroger trompe l'oeil still life painting, learned by copying many masters from the sixteenth century painter Raphael to the eighteenth century artist Nattier.

When I was eight, I tried to unearth the secrets of a master's magic by copying Botticelli's *Birth of Venus*. Twenty years later, I stood sobbing in the Uffizi in Florence looking at the original, holding my stepfather's hand, who had given me my first set of oil paints. He sobbed, too, fully understanding the emotions I was experiencing as I recalled my first rite of passage as an inexperienced child who wanted to become a painter. Copying, in this sense, is part of the history of becoming an artist, but it is only the embryonic phase of an artist's life.

The more we look, the more we see; this is an eternal truth for every artist. The more we see, the more we understand. The more we understand, the more we can apply what we've looked at, what we've seen and what we've unearthed, incorporating it into our own work to make our art richer, deeper, more passionately ourselves. This happens because in that process of seeking and understanding, we, too, have become richer, deeper and more interesting—and, yes, probably more eccentric. Our understanding travels through bones and sinew, muscle and tissue, head and heart, where mysteriously it evolves into something provocative and compelling. At last! What we have studied, researched, observed and learned is magically

☙ IMPROVISATION ❧

Patrick Johnson enlarged his photograph of an industrial site to 8- × 11-inches then made a black-and-white photocopy. With a black marker, he drew on the photocopy, breaking down the image into geometric shapes. He then turned over the sheet of paper to see another composition emerging on the back side of the marked-up photocopy. Using these tools and what he had learned by looking at Mondrian's paintings, Johnson created the improvisation at bottom with a festive tone that contrasts with the mood of the original photo.

transformed into a visual statement all our own, into an autobiographical language of images, colors and lines, all because we did our original looking.

In this challenge, therefore, our goal is not to copy but to alter, simplify and delete. Investigate Mondrian's paintings. Although it would be helpful

to read something of his life and intentions, you don't have to read volumes on his methods. Rather, it is important to look, look and then look some more. Eventually we must, as the late painter and teacher Al Brouillette so eloquently stated, "Interpret, don't identify; create, don't copy."

A NOTE ABOUT USING PHOTOS

When I work from photographs, the photograph is the starting point. Ed Whitney referred to "The Fatal Futility of Fact." Innovative painters aspire to transcend the fatal futility of fact, to invent their own language of symbols, their own sense of color and their own landscapes—inner or outer. True artists are never copyists. Invention and interpretation are always involved. Keeping this in mind, look at the two examples, on pages 48 and 49, of how my students used photographs for this challenge.

⬅ CHALLENGE

➤ *Start With a Photocopy*

Choose a photograph, enlarge it to 8½" × 11" (20cm × 28cm), then make a black-and-white photocopy. Simplify the image and create a composition by drawing on the photocopy with a black marker. At some point, turn the photocopy over to see the composition emerging. You might use the design on the front or on the back. Allow suggestions of subject matter to creep in, if they insist. Also, if you get the urge to engage in creative doodling, go for it. Make a painting that will show your own one-of-a-kind creative personality. Or, use Mondrian as a starting point, integrating his approach into your own.

Suggestions

- Use a limited palette or an analogous palette. Analogous colors, such as blue and green, are adjacent to one another on the color wheel. You might use a series of reds, from orange to blue-red, and add the complement green as a surprise.

- Use both transparent and opaque paint for contrast. If you're working solely in watercolor, apply opaque paints, such as MaimeriBlu's Naples Yellow or Naples Yellow Reddish, adjacent to your transparent paints. Other great opaque paints are: Holbein's Lavender, Lilac, Shell Pink and Grey of Grey and Daniel Smith's iridescent, duo-chrome and Interference paints. Just don't go overboard with the iridescent paints. If you prefer doing collage, by all means, do it. There are no rules!

- Make your blacks dark for contrast. Notice I did not say thick! The best, most luminous darks are transparent. If you prefer opaque blacks, use black India ink, black gouache, black acrylic or black gesso. Mix indigo and sepia, or use Dragon's Blood, for the darkest black possible in watercolor; for another good black, mix indigo with Dragon's Blood. If you use black from a tube, such as Carbon Black, add a dash of color to make it rich.

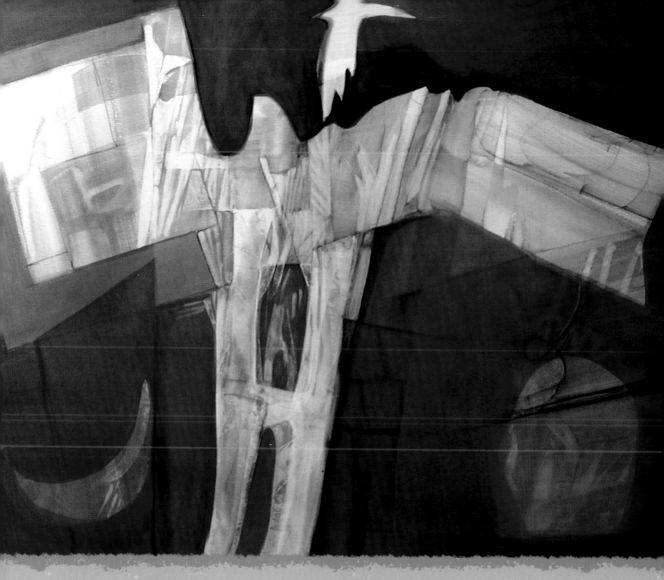

Double Your **Creativity**

Working With Symbols

A brilliant red—toned with grayed red-browns—vibrates
against a strong light shape comprised of blues, ochres and
grayed whites in Virginia Cobb's *Angelangel* (acrylic and mixed
media on paper, 22" × 30"; 56cm × 76cm). Inside the domi-
nant angelic shape is Virginia's name, which resembles a bird
shape. Inside the rectangle, there are repetitions of rectangular
images with a muted blue shape connecting the composition
to the top. Cryptic moonlike symbols on the bottom right and
left further balance this somewhat symmetrical composition.
Nuances of color and calligraphic marks appear in the larger,
dominant shape, providing a quiescent contrast to the brilliant
background color.

> *"We all need to make time for playful inventiveness, to
> surrender ourselves to what is at hand and to bring
> from that experience renewed creative energy."*
>
> ⬥ VIRGINIA COBB ⬥

Linking Shapes
Note the large connecting dark shape that links the background to the head of the sitting female figure and the continuation of that link from the hair and dress of the seated figure to the figure that is lying down holding a doll. Polly Hammett created texture in the background by spraying through a doily; she lifted other patterns with a wet brush in *Memento #1* (watercolor, 22" × 30"; 56cm × 76cm).

If a roomful of artists produces an incredible synergy, what happens when you put only two artists together—perhaps two artists who have different approaches but have known each other a long time?

Sisters and artists Polly Hammett and Virginia Cobb are as different as night and day in their work, and each gives us important insights and reflects a special type of genius. Their artistic ability, instilled by genetic code, came from their mother, as they literally grew up drawing and painting in her graphic design studio. Though they painted together, each was encouraged to find her own artistic voice, explore her own individual expression and seek her unique way of expressing it.

Their earliest experiences of drawing in ink, which meant working in black and white, quickly taught them the importance of value in their work. "In that studio," Virginia reflects, "we learned to respect the two-dimensional surface. The configuration of the surface is your first basic shape; it's the first shape you have to deal with." Although sometimes their paths took them to the same teachers, their sense of self sent them on divergent ways of

painting. Yet, despite their different styles, both exemplify a deep respect for the two-dimensional surface in their modern approach to painting.

With Hammett, the focus is on value and the different ways she uses it to connect shapes. With Cobb, the emphasis is on the shapes themselves. Hammett's approach is subtractive; Cobb's is additive, involving many layers of paint. Hammett began with painting and drawing the figure; Cobb with drawing and painting the landscape. Hammett continued with abstracting the figure; Cobb with abstracting nature to the point that it became totally nonrepresentational. Recently, abstracted figures have appeared in some of Cobb's works.

COBB'S PROCESS: SHAPE MAKING

"As long as I was dependent on outside sources, it was like taking a camera on a trip," says Cobb. "That camera is between you and the experience." Intuitive, improvisational and expressive are adjectives that could be used to describe Cobb's paintings now.

"When I begin, I simply paint and paint until finally I find some form that appeals to me," she says. "Once I select a shape, I assign a meaning to that shape. If it

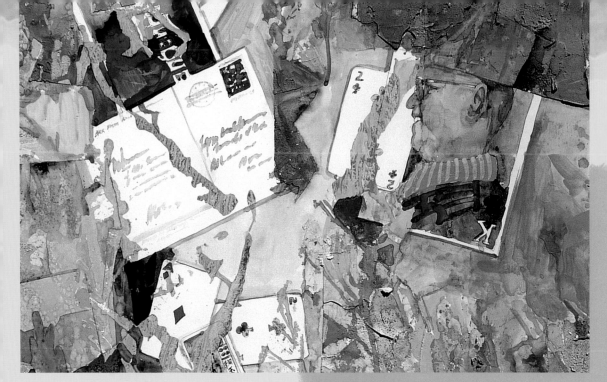

A Little Bit Me, A Little Bit You
In *This Joker's Wild!* ([detail] mixed media on paper, 40" × 30"; 102cm × 76cm), I wanted to portray my friend Lynn McLain and meaningful aspects of our longtime friendship. The king of clubs is McLain, but the poured paint and playing card symbols are all me—all marks of my signature style. In that way, I've linked us forever.

doesn't have meaning for me, I discard it. I ask myself, is this shape too subconscious? The shape must make sense to me on a conscious level to be credible.

"Some of my shapes might appear strange because they don't have any meaning to anybody but me. There are shapes that reappear in my paintings: doughnut shapes, arrows, rectangles and squares." In earlier work, Cobb found that if she drew the silhouette of her name, "Virginia," it looked birdlike. From time to time, that shape reappears in her paintings.

"Often, I'll work with the shapes that I 'find' repeatedly," she says. "In that way, I personalize a painting. In each piece, I make up a story for myself—an essential part of my process. I don't start with a theme. I find it in the painting, and I encourage students to do the same."

An important tool Cobb uses in her paintings is the grid. Often when a painting isn't working, she draws a semblance of a grid over parts or all of the painting with sidewalk chalk. Then she proceeds to paint into and redefine certain areas of the grid to harmonize her painting or create more stimulating shapes and colors.

HAMMETT'S PROCESS: USING CONNECTIONS, PATTERNS AND FIGURES

Basically, Hammett discards local color in her compositions and concentrates solely on integral light and dark connections and patterns, hallmarks of her work. "I've always loved to draw the figure and to make strong value connections," says Hammett. "The first thing you recognize about an object, whether you realize it or not, is its value—and that's because you see shape through value."

Her important first step is simply drawing models from life. "One of my objects is to capture the personality of the sitter," she tells me, "so I make many drawings of a model. After I do quick sketches to try to capture the essence of the person, I do more deliberate contour drawings on layout paper, which is thicker and heavier than tracing

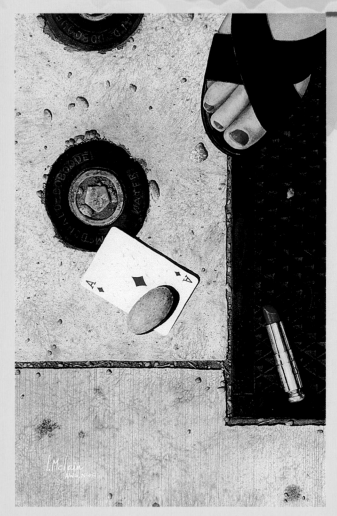

no longer available (I have a sneaking suspicion that Hammett bought it all), you can buy Manganese Blue Hue, which is similar but doesn't have the same lifting properties because of the lack of granulation.

LIFTING OUT LIGHTS AND MAKING PATTERNS

In her next step, Hammett's passion for pattern burgeons as she wets an area and quickly swipes it with a tissue to lift out her lights. Sometimes she draws into her design with a wet brush to make a pattern. Sometimes she stamps, sprays and imprints with other textured materials.

Her efforts establish a strong design through connections: connection of light or dark, connections to the edges of the paper, connections that both link and anchor her figure in the composition. Hammett's last stage is organizing, detailing and refining. She adds stamping, other imprinting and calligraphy to agitate the painting surface and create her exotic patterns, which contrast with the composition's big, flat shapes.

DIFFERENT STYLES: DIFFERENT VOICES

Hammett sums up the differences between her sister's work and her own: "Virginia works with juxtapositions, space and surface. I paint flat shapes and work with connections to change those shapes. I structure with contrast, and she often structures with a grid. We also work in different media; Virginia uses acrylic, inks, watercolor and other graphic tools; I use watercolor, gouache and colored pencils. Virginia layers; I subtract."

paper. Part of my process is taking hundreds of photographs of interiors and backgrounds, some of which I set up myself. From those compositions, I have a gold mine that I can use as a foil for my figures."

In Hammett's second step, she uses a blue pencil and smudges it over tracing paper. She uses this blue-coated transfer paper to transfer her drawing to her surface of choice: five-ply Bristol board. After she transfers her drawing, Hammett begins to paint, using thick, transparent watercolor, almost as if it were oil paint. After this layer dries, she sometimes coats her entire painting with a layer of Manganese Blue. Although Manganese Blue is

Just as Hammett and Cobb are two completely different artists with totally different styles, the work that my good friend and partner in crime Lynn McLain and I do has planetary differences: He's from Mars and I'm from Venus! He's a born Texan; I, a born Virginian. Like Hammett and Cobb, our processes are miles apart, but our quest is the same—to make exciting visual surfaces, to express ourselves through the marvelous plasticity of paint and to use our own symbols in our painting as content. Examine the portraits that he and I did of each other. Each portrait contains symbolic references and reflects our own individual styles.

PORTRAITS IN FRIENDSHIP

I painted a portrait of McLain, *This Joker's Wild!*, on page 53 using the pouring method that characterizes my signature series of playing card and postcard paintings; I also made use of the symbolism that accompanies them. Unlike my typical poured paintings, however, I textured most of the background first with Volume, a soft modeling paste by Maimeri, fluid gesso and a modeling paste by Savoir Faire. My textured surface is a reference to the illusionistic texture in McLain's style.

After this application dried, I poured a plethora of yellows over the surface, then dashed in some Cobalt Violet for contrast. I also used various kinds of salt and spattered paint at different stages to mimic McLain. Next I painted postcards to symbolize the three states we've been friends in: Texas, Arizona and New Mexico. Like postcards, playing cards are one of my trademarks. In this painting, I portrayed McLain as the king of clubs. As a visual segue, I deliberately painted his crown into the background so it became part of the real texture. Our birthdays are symbolized by the two cards: the deuce of clubs (McLain's) and the ace of diamonds (mine). The mah-jong card of jade symbolizes eternity and lasting friendship.

McLain's realistic version of my red toenails in my high-heel shoes, my red Christian Dior lipstick

⚞ CHALLENGE
⮩ *Paint in pairs*

Option 1, inspired by Polly Hammett:
Do two quarter-sheet paintings of the same subject. Work from a drawing done on tracing paper so the image will be the same for both paintings. Change the value of the subject and background in each one. In one painting, make your subject dark; and in the other, light. Also arrange value patterns a different way in each painting.

Option 2, inspired by Virginia Cobb:
Paint an object or part of an object—something you can hold in your hand. Place it in an environment of some sort. Paint it again and again, magnifying it each time and changing the environment. Keep repeating this exercise until the shape itself takes up the entire composition and you cannot see the outer edges of the paper at all. Think of Georgia O'Keeffe's *Jack of the Pulpit* paintings.

Option 3, inspired by Lynn McLain and Betsy Dillard Stroud:
Pick an artistic buddy and paint the same theme, subject, or each other's portraits in your own styles.

and the ace of diamonds are all symbols that reflect my personality. The only thing he left out of *Miz Betsy* on page 54 was a big earring! McLain's signature series are his trompe l'oeil versions of manhole covers painted with transparent watercolor. He builds his layers gradually with a limited palette, texturing with salt and spatter to produce his incredible realism. Unlike the strong use of color and movement and the improvisational qualities associated with my series, his series are dramatic statements about strong value contrasts and are well planned and methodically drawn before he begins painting.

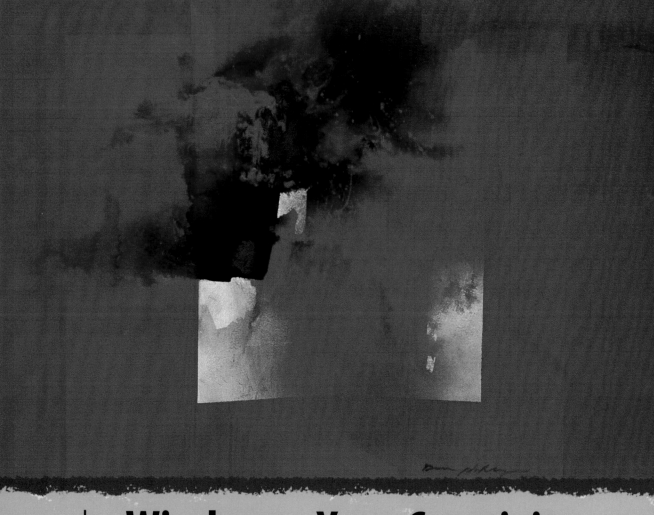

the **Window** to **Your Creativity**

Think of a painting whose theme is windows. What questions and interpretations does that image conjure up? What are some characteristics of windows? Reflections, distortions and flickering patterns of light and dark, ambiguous shapes colliding with sharp delineations. Windows personify mystery and beauty: Think of the intricate stained-glass windows in Gothic cathedrals and the poetry in Tiffany stained glass. Metaphorically, windows remind us of many things. We look through them to see something else, or we look out of them to

Reflecting on a Subject
"Does the subject of a window play a part in the artist's desire to see in or out or beyond? Or is it just me?" asks Mary DeLoyht-Arendt. "Looking through a window integrates the outside with the inside, and perhaps that's why I'm so attracted to painting windows." The focal point of her painting *The Alley Way* (watercolor on mat board, 30" × 22"; 76cm × 56cm) includes the reflections in the glass, as well as the ambiguous objects inside the window and the cast shadows.

see more of the world. And then there's the adage: "A door never closes that a window doesn't open."

With their many implications and the powerful images they bring to mind, this theme is a provocative subject. As a twist, I asked the members of my critique group, the 22 x 30, to pick up their paintbrushes and take on the subject of windows.

INSPIRATION FROM THE PAST

When group member Dick Phillips first reflected about the challenge, he said, "My initial thoughts were of other artists who used windows as an important expressive element in their work. Edward Hopper's haunting windows suggest private, personal worlds within but hidden from our eyes; his paintings of lonely, estranged figures stare vacantly out of apartment or hotel windows at a lonely, estranged world. In his painting *Night Hawks*, we look from outside in the night through large windows into the lighted coffee shop interior, with its isolated late-night customers and staff. Then there are Charles Burchfield's brooding, small eastern-town scenes where storefront windows and doorways sometimes suggest eyes staring back at us. I think of Richard Diebenkorn's early paintings of landscapes viewed through windows from interior spaces.

"During the Renaissance, paintings were thought to be a window to a broader world," continues Phillips. "In this world, there's the concept

of containment, which tells us that the painting is but a snapshot of a larger moment. This concept is alluded to in the framework of the painting, which contains only a small view. There's always the allusion that the view continues outside the painting itself." As an example, Phillips says if the painting contains a view of a mountain, you can't see the whole mountain, only a part of it. "You know it's there, but you just can't see it.

A Cat's Perspective

Interpretive color, linear design and ambiguous spatial arrangements characterize this charming painting of a cat sitting in a window. To create *Under Suspicion* (mixed media, 28" × 22"; 71cm × 56cm), Mickey Daniels started with a drawing of a window and then added her cat and other elements. "Cats are mysterious beings," she says. "There's a bird's nest inside the window and a feather, whose ambiguous juxtaposition mimics a cat's behavior."

"In the late nineteenth and early twentieth centuries, artists like John Marin changed this concept," says Phillips. "They broke away from the idea of the picture plane as a larger world and presented it as a two-dimensional world with nothing beyond the edges of the paper or canvas. They seemed to be saying, 'This is my world right here, contained within the planographic picture plane. There's nothing beyond what you can see.' In essence, this thought process objectified painting and made painting itself the object."

SIMPLE AND COMPLEX CONTRASTS

Windows remind us that oftentimes the simplest, most ordinary things around us can be the most complex and intriguing things to put in our paintings. Like life, windows can be transparent, opaque and translucent, all at the same time. And like a good painting, they create a dialogue with the per-

Mindscape

As she worked on her painting *Spaces In-Between* (watermedia, 40" × 30"; 102cm × 76cm), Betty Braig listened to the news. Feeling bleak, she said, "I expressed my anxiety in spontaneous movements and gestures in the paint to mimic shapes and attitudes of the birds." Her intention was to use the window concept to contain a mindscape that we can enter or retreat from at will, yet be stabilized, as she became stabilized through painting.

A Room With a View
Miss Alice Ware was one of the stellar citizens of Lexington, Virginia, where she died just after celebrating her one hundredth birthday. In *The Windows of Her World* (acrylic on illustration board, 20" × 30"; 51cm × 76cm), I used van Gogh's colors to render her sitting in her favorite place, at the top of her staircase, looking out the window at the Virginia Military Institute and the streets of Lexington, where she spent over eighty years of her life.

son looking into or out of them. Often, they appear to tell stories of people who looked out of those windows. Personally, I'm attracted to broken windows in old, abandoned houses that epitomize the enigma of those who lived and sometimes died there. I frequently discover that I can look through a broken window only to see another window that looks out on another landscape. After all, isn't being creative a lot about periodically changing your view?

CHALLENGE

Look Through a Window

Look at the variety of concepts in the paintings on the previous pages done by my critique group. This variety represents but a microcosm of the many interpretations you can do. Your interpretation will be completely different than our expressions or those of painters around you. If you belong to a critique group, challenge them with this exercise. If not, do the creative challenge yourself or with a painting friend. Ask yourself the following questions, and remember that this challenge is about what windows mean to you.

- How have windows lightened or darkened your life?
- Do you use them in your paintings?

- What thoughts and observations does the word *window* evoke in you?
- How can you express those thoughts and observations?
- Do you think of the word *window* metaphorically and in an abstract way, or do you prefer to do a representational painting in which the window is the subject or at least part of a bigger subject?
- Will you present your feelings symbolically or realistically? Perhaps you could combine both ideas in a fascinating way.

BURT · AWS/NWS

Color Your World Creatively

Even before we've learned to master all the basics, we begin to develop a personalized approach to color. That approach, created by a host of internal and external stimuli and influences, is both subconscious and conscious. Developing an expressive use of color is an important step in creating a recognizable signature—our own special way of viewing and portraying the world.

Three artists who have distinctly recognizable approaches to color are Dan Burt, Carl Dalio and

Judi Betts. They incorporate in their work a wisdom based on a thorough understanding of color and an intuitive ability to make a statement using color. Their use of color also possess an indefinable, *je ne sais quoi* quality that gives their work character.

Two to Tango
High-key colors collide in dynamic ways in this playful tango of warms and cools, as a series of connected small darks weave through the composition like a line dance in Burt's *Signs of the Times* (watercolor, 22" × 30"; 56cm × 76cm).

Combining knowledge and instinct led them to explore a more subjective way of using color. To explore color, I had to delete the caveats, those clichés that can obstruct and confuse you when you decide to experiment. Some of them might be "never use black," "get Phthalo Green off your palette" or even "green is the complement of red." All these statements must be examined in context.

COLOR HAS MEANING

As part of your exploration of color, tap into its symbolic connotations, as well as your own personal connections to various colors. For example, the color yellow for me conjures up memories of the summer, when I was nine, during which I spent a month in bed with pneumonia. As I lay in bed, I could see the harsh yellow light—a Quinacridone Gold with a touch of purple—flickering through the window shade. And, of course, the color purple has symbolic meanings. It's heraldic, spiritual and passionate. The color blue can call to mind "getting the blues" or "being true blue." It can also represent truth and devotion. Throughout art history, the Madonna has always been depicted wearing a blue cloak, referred to as the cloak of heaven.

What images come to mind when you contemplate a certain color? Is there a particular color you hate? Even that prejudice might be symbolic if you reflect on it long enough. If thoughts come to mind about certain colors as you read this article, jot them down. They may prove useful when you develop a painting or when you explore them in context with certain ideas.

DAN BURT

"Burnt Umber is canned mud," says Dan Burt. He admits that his palette was grayed during his many years as an oil painter and that he really wasn't "into" color. When he switched to watercolor, he reconsidered his palette. "I went through a transi-

tion," he explains, "when I realized that my color seemed dead." Eventually he discarded all the earth colors, mixing his own complements when he wanted grays. "Yellow Ochre and Burnt Sienna were the last to go," he says, "because I realized I get the high chroma and vibrancy I want with Alizarin Crimson and New Gamboge."

⬇ CHALLENGE
⇒ *Use Unexpected Color*

Option 1, inspired by Dan Burt:
Paint a sunlit day, using color as light and value. Save areas of pure white and develop your darkest darks around them to create an interesting focal point. In the midtone or gray areas, use a combination of direct painting on dry paper and wet-into-wet techniques. The grays and midtones will balance out the brilliant transparent colors and darks.

Option 2, inspired by Carl Dalio:
Change a day scene into a night scene. Use a photograph you've taken or a finished painting of a particular time of day as your starting point. Start by making the most intense light the least intense. Make up a pecking order of intensity that will guide you in converting the image from light to dark. As you do so, be aware of the temperature of a color. Think about reversing everything about the light that you can. For example, change the coolest light to the warmest, the darkest light to the lightest. Replace the sun with the moon.

Option 3, inspired by Judi Betts:
Draw a series of different-sized abstract shapes on your paper, making the lines curved between the shapes. Paint each shape a light midtone color. Use only transparent colors. After this layer dries, draw a realistic subject on the surface and fill the newly created shapes by painting the complement of each color on top of the underpainting. Watch the colors zing!

When you look at Burt's paintings, shimmering light and color sparkle and bounce across the composition. In *Gloucester Dreamscape* on page 60, for example, areas of pure saturated color straight from the tube sing next to stark, brilliant whites, which shift into luminous grays in which tiny drops of pure pigment float. The grays drift into transparent, provocative darks, made by combining Alizarin Crimson and Phthalo Green with a little Phthalo Blue. Burt's skillful placement of small, irregular white shapes (untouched areas of the paper) leads us through this composition. We dance the dance of light. It's this artist's artful arrangement of shapes and his intuitive use of color that suggest and imply rather than describe the brightness of a sunny day.

Surprising Color Choices

Expressive use of bold color with unexpected juxtapositions characterize the works of "colorsmith" Carl Dalio. With bravura, he chooses glowing pinks and bright emerald greens to epitomize light in this intriguing night scene, *Starlight in Victor* (watercolor, 11" × 14½"; 28cm × 36cm).

CARL DALIO

"When I think about color, it's like pearls on a necklace. When you talk about one pearl, it leads you to another," reflects Carl Dalio. "*Starlight in Victor* [above] could be about my grandfather's house at Christmas, with the warm lights of the interior and the Christmas tree casting a glow into the dark exterior where we children played outside.

Double Your Complements
In this soft and poetic rendering, Judi Betts uses the primaries and their complements. She exploits variety of shape, size and value, creating lovely neutrals in the background in this enchanting floral, *Stars and Stripes* (watercolor, 15" × 22"; 38cm × 56cm).

I remember the contrast of the warmth and the cool. Unfortunately, color gets washed out on your voyage to adulthood and it becomes necessary to go back to that direct innate language you were born with—for if you do, your paintings will breathe.

"All my paintings have a story line," Dalio continues, "and that story line is both emotional and narrative. In *Starlight in Victor*, intense color is the language I use to express my emotions." In this painting, notice how the blue-purples and turquoises are punctuated by dark violet-pinks, and how the strips of emerald green speak softly, yet paradoxically shout vibrancy by their juxtaposition against the purples.

JUDI BETTS

Another example of masterful use of color is Judi Betts' *Stars and Stripes* above. A mélange of gorgeous color, handled in her lyrical style, this painting highlights the use of double complements with their placement against the muted neutrals made by mixing those complements. Interspersed in the painting, Betts includes her characteristic abstract shapes, poetically providing ambiguity and compelling forms to activate the surface. "Colors can be lullabies or symphonies, but what makes them sing in either case is the position of complementary colors," says Betts. "Colors surrounded by their complements cause an explosion! It can be subtle or monumental."

For this creative challenge, pick one, two or all of the exercises suggested on page 62. Like a wonderful novel, color weaves a narrative yarn as it tells its own story. Like a melody, it has sound and rhythm. What story do you tell through color?

CHALLENGE
Start With a Mother Color

My students often kid me about my Virginia accent, so I like to refer to this as the "Muthah Cullah" exercise. Before you begin, select a "mother color," a color that must be in everything—every shape, every color mixture, etc.—one way or another. You may drop it in with other colors, or you may paint your whole painting using only that color in different values. In addition, you may add black, white or gray to your mother color to change it.

To start, do a contour drawing of your composition on a full sheet of watercolor paper. Then add geometric images over your drawing. You may also use tape or torn paper to augment your design. When you do your painting, change the color and/or the value each time you come to a geometric object. Use watercolor or acrylic paint, and layer the paint as many times as you wish until the color satisfies you. Use as many colors as you want as long as the mother color is present in each of them.

Using MaimeriBlu Green Blue as my mother color in *Muthah Cullah's Baby* (watercolor 30" × 22"; 76cm × 56cm), I began by drawing the still life and blocking in the color of the roses with thin washes of the mother color and other colors dropped in to let them mingle. I worked around the painting for color harmony and began to stamp with a carved linoleum block to emphasize the flatness of the picture plane. Green Blue is in every color in this painting—but in different saturations. I used many other colors: Verzino Violet, Ultramarine Dark, Cadmium Yellow Deep, Neutral Tint, Permanent Red Light, Crimson Lake and Iridescent Gold.

65

Unmask Your Creativity

"All art as well as life is an abstraction. How dull it would be if all aspects of both were predictable or recognizable."

═ JASON WILLIAMSON ═

The secrets of civilizations past and present may partially lie in the masks its craftsmen have created. For millennia, one of the earliest art forms, the mask, has served as adornment and disguise. Sculpted masks adorn the friezes of many an old theater and remind us that we're witnessing illusion. During the Renaissance, masks symbolized broken dreams. In Mexican culture, an artificial face placed over a real face transforms the wearer. A mask with the face of an animal, for example, transfers that animal's power to the wearer. In other cultures ritual masks are worn by performers in ceremonial dances representing rites of passage. And around the world, death masks are used to present the dead to the afterlife.

METAPHORICALLY SPEAKING

What is this inherent fascination with masks? "[They] fool us into thinking we are separate from one another," says poet Tom Cleary. "Without them, we are one soul." Metaphorically, masks represent all the faces we hide behind and, paradoxically, the personae we might wish to adopt.

The Phoenix Art Museum once hosted an exhibit of hand-sewn masks that were some of the most provocative images I'd seen in a long while. Each mask was a masterpiece of exquisite

Create Mystery by Juxtaposing Dissimilar Objects in a "Mask" Still Life

By painting an object not ordinarily associated with a mask, you create tension and contrast. You make the viewer ask, "Why?" Thus, the visual dialogue—that intriguing dialogue between the viewer and the painting—begins. In *Unsuspecting Geisha* (acrylic and watercolor, 30" × 22"; 76cm × 56cm), I drew the doll and then, as an afterthought, the masks. I had painted with transparent watercolor, and the painting lacked the dashing quality I was after. I began to add opaque acrylics. I poured on top of it with transparent washes of Phthalo Blue acrylic and Ultramarine acrylic. I even shot it with a hose. Finally, I punched it up with patches of red-orange and Cadmium Red in places throughout the composition, and, at last, I liked it!

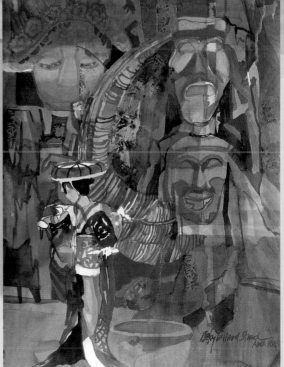

An Example of Fine Design

A subtle palette of Phthalo Turquoise, Phthalo Blue and Quinacridone Gold provide the background for Jo Toye's *Cheyenne* (acrylic on watercolor Clayboard, 11" × 14"; 28cm × 36cm). Grays made from gesso and black acrylic complement the blues, and a geometric framework broken by the dog's paw anchors the painting. The surface is a scintillating mixture of lines and colors, and the dramatic contrasts of the grays, blacks and color pay homage to the artist's design expertise.

handiwork and had a different emotional impact. Beautiful white beads twisted around eagle claws; feathers grew from eyeless sockets decorated with a mixture of shells, glass and other precious materials. Enigmatic faces emerged from mixtures of stone, brightly colored paint and cloth that merged into sometimes demonic, sometimes benign images.

For this creative challenge, think about what the word *mask* means to you. When I hear the word, I think of the sleeping masks that my family wore when I was growing up. We called them "sleep shades." What images does the word evoke for you? On these pages, we'll explore the work of three other artists who will show you their interpretation of the subject: mask.

MASKING OUT FINE LINES

In Jo Toye's painting *Cheyenne* on page 67, a gift for her brother who lost his dog, the word *mask* takes on several meanings. She chose to use her masking technique as a wordplay on the theme. To begin,

she drew a complex network of lines using a masking pen and then switching to a brush and liquid masking fluid to do small detail work. After the initial masking dried, she poured paint over the surface and allowed it to dry. She then repeated her first and second steps. After this second layer of masking dried, she began adding her darks. Next she glazed over the areas that had been masked out. Her final step was to carve out the shape—in this case the shape of a dog—by negative painting using opaque paint.

MASKING AS TOOL AND SUBJECT

Use frisket to mask out interesting designs in your painting. Lynn McLain's painting *Mask Man* on page 66 is a double pun, both literal and visual. He uses frisket in his well-known paintings of manhole covers, the *Road Chatter* series. When I asked him to create a painting based on the theme "masks", he complied by injecting his sense of humor into his depiction of *mask*. With a sense of irony, he places us in his usual cement setting to display his unusual subject. McLain plays with the word *mask* by depicting a spilled bottle of masking fluid. If you look closely, you can discern the subtle shapes of actual masks in the spilled fluid.

Create a visual pun or a humorous painting based on the theme of a mask—an art tool or a disguise or both. Or find or create mask shapes in an unfinished or unresolved painting.

◄ CHALLENGE

➥*Make a Narrative Painting of Your Life Including a Mask of Some Sort*

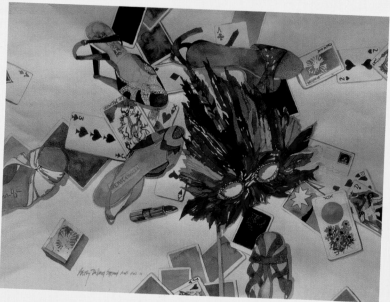

In *End of an Era* (watercolor, 22" × 30"; 56cm × 76cm), symbols abound to describe a rite of passage in my life. The high-heel shoes refer to episodes in my past and are constantly surfacing in my dreams. The cards tell the rest of the story. The mask is near, not in, the middle of the painting to remind me that the past needs to remain in the past. This piece was painted directly on the paper. The only techniques that may not be obvious are the stampings on the cards and the use of interference paint to create subtle grays.

Shape Up Your Creativity

"Form is the visible shape of content."

⬗Ben Shahn⬖

Feel the Energy
Various dark red shapes contrast with a bright yellow color field to make Lynn Mikami's spontaneous painting come alive. Energetic dashes and strokes of color complete the statement in *Chopsticks* (acrylic on paper, 22" × 30"; 56cm × 76cm).

One might argue that the shape of creativity is amorphous, a formless question mark until the creator makes his or her mark. Once made, that question mark is capable of assuming any proportion, any dimension, any silhouette. Although this statement sounds paradoxical, without a doubt the shape of creativity is unlimited and undefined until the individual artist puts brush to paper, torch to steel, finger to clay or chisel to stone. Some observers insist that geometric shapes are masculine and organic shapes are feminine, an intriguing manifestation of yin and yang. Famed granddaddy of watercolor painting Edgar A. Whitney defined a good shape as "an object of different dimen-

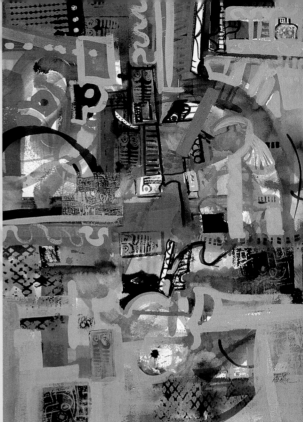

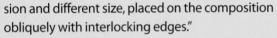

Repeat Shapes for Best Results
A cool palette dominates Pat Woolley's geometric paint-ing *Journey Within* (acrylic on paper, 22" × 30"; 56cm × 76cm). If you divide the composition into four equal quadrants, each is designed somewhat differently, yet contains a bit of color from the other three. Woolley ties the composition together by repeating shapes.

sion and different size, placed on the composition obliquely with interlocking edges."

Just as a distinctive line indicates a Rembrandt or a Tiepolo drawing or as a particular way of using color indicates Gauguin or van Gogh, so can a distinctive shape help define a style. What are the shapes most often repeated in your painting? If you've painted for a while, patterns emerge. What does your brushstroke look like?

A CHALLENGE TAKES SHAPE

This past summer I was in the painting doldrums, certain that never again would I have an original idea. Glumly, I flipped through channels on the television, looking for the escape of a good movie. Suddenly, the screen filled with a shot of a familiar figure painting. Picasso! He was sitting in front of a screen with a brush in his hand. I pushed the information button on my remote, and the title of the movie *Mystery of Picasso* came up. Goose bumps arose on the back of my neck as I watched

Picasso put a shape down, then brush through it. Sometimes he drew a whimsical shape of a fish, sometimes a contorted figure. Often he painted through the image he had drawn, desecrating it. Sometimes he brushed on ambiguous shapes in intervals and began drawing over them.

One shape flowed into another and another and another. Sometimes he obliterated a shape with the deft sweep of his hand, and sometimes he painted over a shape with black. I felt a rush go through my body. It was back. Inspiration—the creative impulse—was back. Immediately, I began to form an idea about shape-making that I would try in my upcoming workshop at the Scottsdale Artists' School. Three workshops later, my idea flourished as I watched student after student turn out an original painting exploring the "shape mak-ing" process.

VARIETY IS THE SPICE

Here's the challenge I pose to my classes and to

70

you, too. First, make shapes using watercolor or acrylic and different-sized brushes to make sure you get an interesting variety. Vary the sizes and dimensions of your shapes, making sure to touch the edges of the paper on all four sides with a shape or a line of color while leaving a little white of the paper showing. Also vary the colors of your shapes. It may be best to decide on a color scheme like a triadic palette or an analogous one before you begin. Try dropping a second color in one of the shapes while the first layer is still wet, or apply a wash of clear water in a shape, then drop in several colors and let them commingle. You can even glaze over your shapes with another color after they dry.

Let the painting dry. Then use black India ink, gesso, gouache, acrylics or watercolors to make a contour drawing over the shapes. If you are mixing your blacks, make sure you use colors that are dense enough. For example, if you are using Ivory Black, which is a warm, transparent black, add some other colors to it to boost its intensity and covering capacity. You don't have to work with a subject in mind as you begin to draw. For *Spirit Dancers* at right, the figures evolved at the end. I had no preconceived notion of what subject (if any) I would paint.

Grays play an important role in this exercise. Using "palette mud" (neutrals made from the colors on your palette) and/or opaque grays, add areas of neutrals to contrast with the lovely color patches and the black ink to give the eye a place to rest. Complete the painting by adding other shapes and textures if you need them. As you paint, let your imagination roam. Listen for intuitive nudges—words or images, colors or phrases that might suddenly flash into your mind. Pay attention, for

↯ CHALLENGE
⇒ *Exploit Form and Pattern*

To create *Spirit Dancers* (acrylic on paper, 22" × 30"; 56cm × 76cm), I first applied masking tape onto a sheet of Fabriano Artistico paper at random and began to paint various sizes of shapes in acrylic. I intentionally left some of the paper blank. For my color scheme, I used a series of complements: red/green, yellow/red-purple and blue/orange.

Next, I drew an ink contour drawing over the shapes. After the ink was dry, I began to paint in some areas with opaque grays. I also used neutral gray and warm gray. When I wanted to make the gray more interesting, I simply added a bit of one of the colors on my palette to the gray. As I drew, I allowed images to emerge from my subconscious. The figure in the middle is abstract, whereas the silhouette and the mask above are more realistic.

Finally, I made stampings of images I'd carved into linoleum blocks, which I loaded with thick, juicy paint. I also toned down some of the too-dark shapes by painting over them with grays, including the rectangle going through the circle on the bottom left.

those flashes are a connection to your creative spark, your source. When you feel as though there is nothing left to do, stop.

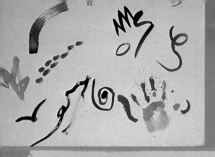

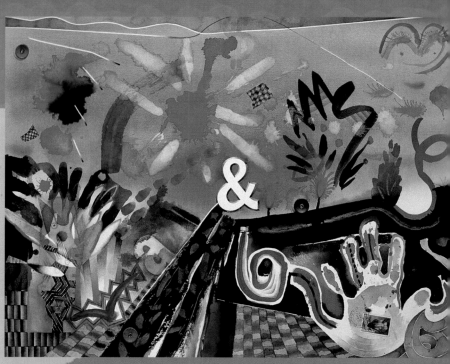

From Marks to Masterpiece

Starting with the random marks made by his workshop students above, Miles Batt infused *East of Ampersands* (watercolor on paper, 21" × 29"; 53cm × 74cm) at right with bold color and design, marrying the calligraphic marks of his students with signature elements of his contrived visual language, including the *a*, the ampersand and a button.

Inside the **Creative Mind** of "Batt Man"

Miles Batt's painting style is unmistakable. As a former sign painter, his dexterity in wielding a brush is unsurpassed. His paintings possess extraordinary color, often unexpected—and thrilling—color juxtapositions and bold design, coupled with his expressive and whimsical treatment of subject matter. Moreover, all his work contains a certain ambiguity.

Batt teaches the tenets of creative painting, the first of which, according to H.W. Janson, involves "a leap of the imagination." Creative painting is not about the literal copying or repetition of another work, and, most importantly, it always reveals the

"Either you're imitating or you're innovative."

⬛ **MILES BATT** ⬛

personal heart and hand of the artist. Batt puts it this way: "Creative painting is a happy marriage between the intellect and the emotions."

His workshops are revelations, for each day he presents an intriguing exercise in creativity, designed to make students think for themselves.

৵ JOIN IN ৵

Miles Batt asked his students to make a mark on the same sheet of watercolor paper. He then deftly unified their marks into a compelling composition.

⟨1⟩ START WITH RANDOM MARKS

Using personal color choices, students made random marks on Batt's paper.

⟨2⟩ EXPLORE COMPOSITIONS

He analyzed the marks, traced them onto a sheet of tracing paper and drew possible composition solutions.

⟨3⟩ BEGIN COLOR SCHEME

He painted segments of the composition using an expressive but logical color scheme that harmonizes with his students' marks.

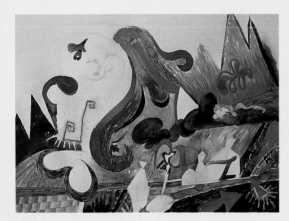 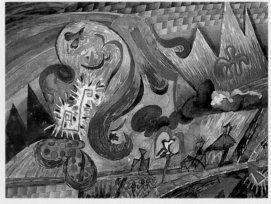

⟨4⟩ BRING THE MARKS TOGETHER

As the painting progressed, he incorporated the random marks into a coherent visual statement.

⟨5⟩ CREATE A UNIQUE WORK OF ART

The finished painting, *A.M. Coffee* (watercolor on paper, 21" × 29"; 53cm × 74cm), is a kaleidoscope of color and provocative design. Bright, bold and beautiful, it's a quintessential creative painting, a truly unique work of art. If you question this, just ask yourself, "Have you ever seen a painting like this before?"

Each day, he presents a challenge that illustrates an important point or points about the basic elements needed to execute a good painting, or that plays a critical role in creative painting. As Batt says, "The greatest asset in producing and/or appreciating creative painting is a tolerance for ambiguous form."

LEARNING AND LETTING GO

In his workshops, Batt uses the word *core*, which he says is an acronym for four necessary steps in creative painting: create, obliterate, reorganize and evaluate. Although he welcomes ambiguity in his work, there's no ambiguity in his statement concerning painting. It's black-and-white, a concrete demarcation, a declaration about the creative process.

According to Batt, "Either you're imitating or you're innovating. As you teach, you get a clearer focus on where people are in their art. First, you must master the medium. Second, you must draw on that repository of understanding that comes from knowing about and observing all the artists

◢CHALLENGE
⇒*Make Random Marks*

Get a few friends to make random marks on your watercolor paper. Don't tell them what to do or what marks to make. Let it be spontaneous. Then get busy and create a dynamic painting!

before you. Then, if you're tied to a subject, you can still be creative in that genre by collecting information and making a larger leap exploring your subject matter. That large leap comes from asking, 'What if?'

"Painting is like a poker hand," he laughs. "It's about keeping and throwing away. And that means you must simplify. The fun in contemporary painting is putting 'Mairzy Dotes' in a line of 'Ave Maria' and making it work."

PULLING IT ALL TOGETHER

Batt challenges students—and himself—to "make it work" in one of his favorite workshop exercises, "Random Marks." For this group project, each student in his class paints an expressive mark on his paper, and from this mélange of calligraphy, Batt begins and completes a painting—a prizewinner, more often than not.

How does he do it? By finding and manipulating contrasts. "Contrasts are the fundamental bulwark of all good painting," says Batt. "Contrasts are available to us by understanding similarities and opposites, which we can now play against each other, but to do this we must change our frame of reference. There is a balancing of forces to bring contrasts in concert with the rest of the painting. Either you'll discover a painting idea through the process, or, having confidence about what you're doing, you may start out with imagery. It works either way."

TO BE A CREATIVE
∽ PAINTER ∽

◆ Be willing to take chances.

◆ Do things that are different.

◆ Explore every period of your life and every facet to understand yourself.

◆ Analyze your ideas. "Once you analyze your ideas and have their 'anatomy,' " says Batt, "you can freely access those ideas and make creativity happen again. Through repetition [doing a series] you find your strategy. Many excellent ideas may be lost with only one version."

A Study in Contrasts

In *The Blue Hour* (watercolor and casein on paper, 24" × 34"; 61cm × 86cm), Stephen Quiller evokes mood both through his choice of color combinations and the use of multimedia washes. Juxtapositions of neutrals in the foreground and in the background glow against the coral strip of light on the land and behind the trees. Subtle patches of blue light shine through the trees while a wider strip in the foreground is a counterpoint to the transparent snow. The black trees provide a final dramatic touch.

Creativity: the **Black, White** and **Gray** of it

"Sometimes it is like keeping the storm door shut with one hand while painting with the other, letting the known out so that the unknown may enter."

⇒ PAUL JENKINS ⇐

Coloring books aside, as children most of us drew with pencil or pen. Essentially we learned to look at the world in black and white. Even now, a stark line of black on a white sheet of paper gives me a thrill, and when I reflect upon the beautiful, pristine contrasts of my early drawings, I realize how much they've influenced me as an artist. Yet it is a middle value that is missing from those early drawings, and as I have matured as an artist, it is the haunting beauty of gray that fills my thoughts and that I now incorporate into my paintings.

Known for his captivating landscapes, Stephen Quiller uses gray not only as a neutral to set off his

luscious and harmonious color juxtapositions, but also as a beautiful color chord itself. "The word *gray* can be used by an artist in a couple of different ways," says Quiller. "It can be used as a substitute for the true terms *neutral* or *neutralize*. In *The Blue Hour* on page 75, for example, I used complements and near complements to 'gray' [neutralize] colors by adding Cerulean Blue to Cadmium Red Light, Ultramarine Blue to Cadmium Orange, and Ultramarine Blue to Vermilion."

The title of Quiller's painting refers to that evanescent time before nightfall, just moments after the sun goes down, when a whisper of blue casts over the landscape, a magical and mysterious light that challenges every artist to catch its fleeting nuance.

BRILLIANT CONTRASTS

For contrast and drama, Quiller chose black for the trees in *The Blue Hour*. "Renoir called black the queen of colors," recalls Quiller. "Black can be used as a foil to set off color and give it a gem-like quality. Here I used black casein as an opaque to set off the transparent tones."

Quoting another master, Robert Henri, from his book, titled *The Art Spirit*, Quiller continues, "There is a power in the palette that is composed of both pure and grave [neutral] colors that makes it wonderfully practical and presents possibilities unique to itself. In such a palette, if the grave and pure colors are used successfully in a painting, the results are astounding."

In other words, to paraphrase Henri, grayed-down colors become the essential foil to enhance

brilliant colors. In their juxtapositions, the grayed colors become alive, appearing to move as if in perpetual motion—at least, as he puts it, in how they affect the eye. For, according to Henri, "They are indefinable and mysterious." Paradoxically, he explains, an arrangement of bright color next to a neutral color can cause an extraordinary phenomenon in which the eye sees the neutral as being brilliant and the brilliant color as being less saturated.

THE POWER OF A SUBTLE PUNCH

Quiller lives in Creede, Colorado, and there are many months when he paints in his studio because of the weather. During those months he often develops his paintings from facile studies he makes as he walks his hallowed woods. He uses a lithographic crayon for these quick and energetic explorations of the landscape. Quickly drawing a scene forever fixes it in his memory so he can

◀CHALLENGE

⇒Paint a Gray Landscape or Paint an Abstraction in a Multitude of Grays

Option 1, inspired by Stephen Quiller

Capture the emotional spirit of nature by doing a landscape using grays made from mixtures of Ultramarine Blue and Cadmium Orange, Cerulean Blue and Cadmium Red Light, and/or Ultramarine Blue and Vermilion. Make sure you have a strong black to provide contrast against the grays and the colors in your painting. Make some passages opaque, some transparent and some translucent. If you're working in acrylic, thin gesso with water and apply it over the area that you want to be translucent. Translucent passages allow the form underneath to show but remain a bit ambiguous, whereas transparent passages show all the form. If you like, use a variety of media.

Option 2, inspired by Betsy Dillard Stroud

Stroud's Challenge: *Gray on Gray on Gray* (watercolor on paper, 30" × 22"; 76cm × 56cm) began as a practice sheet for a workshop I was teaching in El Dorado, Alaska. The gray rectangles at the top of the paper were all painted differently, and all comprised different complements and color triads. Some rectangles were executed wet-into-wet. Some were glazed. One rectangle is Ivory Black.

To start, I stamped with a variety of neutrals from my palette and began adding opaque paint around the neutrals at the top. Notice that the somewhat opaque beige neutral made the transparent rectangles glow with color. I used so many color combinations to make grays that every gray turned out a little bit different. At one point I used American Journey Coastal Fog color to surround the rectangles, and then I tried to reproduce that color by mixing Sennelier Chinese White, Cadmium Red,

Phthalo Green and a little Raw Umber together. (I came close.) At the bottom of the painting, I painted a wash of Indigo and, before it could dry, I added brown madder. Then I laid a stamp over the washes and let the painting dry. After that layer dried, I added more stamping, with opaque and transparent darker grays. Lastly, I painted into the stamped area with opaque mixtures.

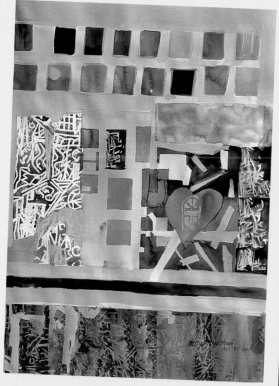

explore different color relationships and compositions. The crayon enables him to suggest midtones and darks because of its oily nature. Drawing rapidly and freely on-site, he's able to capture the "gesture" of the landscape he's observing.

Years ago, as Quiller and I walked through the Dallas Museum of Art, we stopped abruptly at a small painting by Édouard Vuillard, both of us transfixed. The painting was a masterpiece of neutrals whose subtlety and power reached through the canvas and stopped us in our tracks.

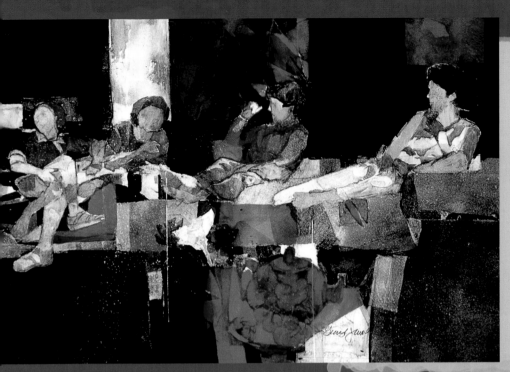

Painting a Memory
George James remembers a lovely time in England when his wife and friends ate cherries, throwing the pits into a tin cup. Bright red dominates the background of *Cherries, Tea, and Pits* (acrylic and watercolor on Yupo, 26" × 36"; 66cm × 91cm), and the neon-orange underpainting exploits the warm memory, adding intensity to the red. The division of space is masterful, with the figures making a graceful arc across the composition. The lights are lifted out, and the textures come from his use of a sponge applicator (brayer).

the **Creative Lift**

As painters in watermedia, we begin by putting down one brushstroke after another, building up color to reveal an image. We typically remove color only to correct mistakes or reclaim lights. Dragging a thirsty brush through wet paint or scrubbing a dry area with a stiff brush, we lift layers of paint to reveal the white of the paper or a previous layer of color. But this technique can offer us so much more. Lifting out color to create texture and atmosphere is a far more daring, more imaginative use of the technique. You can use lifting techniques on a variety of surfaces, but I focus on award-winning artist George James' unique approach to lifting and his exciting experiments with Yupo paper, a slick synthetic surface that absorbs very little paint and allows you to lift off areas of color easily.

"There can be no exquisite beauty without some strangeness in proportion."

⇒ Sir Francis Bacon ⇐

SETTING THE MOOD

As I talked with James about his intriguing paintings, we discussed why the nontraditional lifting technique thrills him. For James, who was once a photorealist, working on Yupo and lifting paint constantly pushes him in new creative directions, satisfying an urge to create both texture and an enigmatic atmosphere for his figures to inhabit. Anyone familiar with James' paintings recognizes

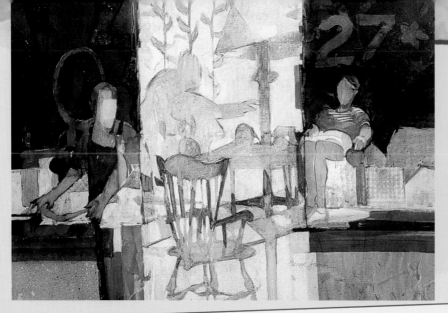

Taking Chances

In *The Path of the Melody* (watercolor on Yupo, 26" × 36"; 66cm × 91cm), James develops a dark pattern on both sides of the composition, then bravely breaks the dark with a light vertical drop. He also plays with our imaginations by distorting the lamp and making it big, while making the figures distinctly smaller.

⚜CHALLENGE
⇒*Make a Connection*

Inspired by a Rex Brandt exercise, George James challenges you to take a horizontal painting and turn it into a vertical one using techniques described here and working on Yupo paper. Block in your basic shapes, then go back

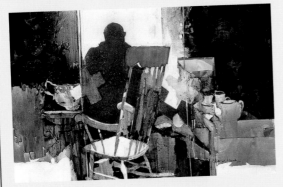

and lift and paint to complete the design. In *Tea Time* (watercolor on Yupo, 26" × 37"; 66cm × 94cm), about the death of his parents, James exploits value contrasts, dividing the dark sides of the painting with a passage of brilliant light that illuminates the middle ground and indicates the focal point. The chair represents his mother and the dark silhouette his father. To paint on Yupo, James recommends using:

- a good facial tissue to lift out color
- a sponge applicator (or brayer) to roll over the surface, for lifting and burnishing—he used sponge hair rollers until he discovered sponge applicators
- paint that is thicker than usual
- a brush filled with water to draw shapes in dry paint

the ambiguous nature of lost and found images indicative of his work. Despite the abstraction, the shapes are recognizable, grounded in a complex but strangely familiar background filled with juxtapositions of shape and color.

James explains his approach this way: "Every time I touch a piece of Yupo, it's virgin territory. It's a little like walking across a desert and finding

a television set, and then walking a little farther to find the plug that turns it on." In his work, James focuses on establishing value with color. Add to that a good narrative and a dynamic composition, and he's got a formula for success.

A FORGIVING, EXCITING SURFACE

A spontaneous and intuitive painter, James begins

the same way as the rest of us—with a brush-stroke—and, like a jazz musician, improvises with each subsequent stroke. "The strokes happen fast on Yupo," he says, and it encourages him to push the envelope. "Simply put, I pick a place on the paper to start and then begin adding intense color. That's when the journey begins. I find my way using both constructing and deconstructing techniques." Creating the values that constitute his contrasts, James uses a sponge applicator (or brayer) to brush down washes by making them flat, then lifts out color by applying a tissue and brushing the area again. He repeats the process until he gets the color value he wants. To lift, James sometimes draws on the surface with a water-filled brush, then repeats the rolling process with the sponge applicator.

James admits, "I fiddle around with the basic issues of value, color and all the other elements that every painter considers." Much like a treasure hunt, Yupo appears to lead James to the pot of gold, a beautifully constructed painting.

❦CHALLENGE
⇒*Lift to Create Texture*

Start with a light midtone underpainting on hot-pressed paper, let the surface dry thoroughly, then coat the entire painting with a mixture of half matte medium and half water, mixed thoroughly. Before drawing on the surface, make sure it's completely dry. The matte medium surface allows you to:

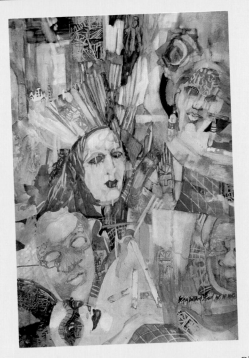

- lift color back to the underpainting with water and a facial tissue

- give your painting an exciting texture, as the acrylic matte medium changes the surface, but be aware that you'll have less control of your washes.

- experiment with stamping, drawing with water, imprinting and lifting out color. Just as with Yupo, you can lift and repaint, lift and repaint, ad infinitum.

- spatter paint and water to create a textured underpainting. As you apply subsequent layers of paint, keep in mind that this underpainting will be your lightest light

In *Through a Glass Darkly* (watercolor and matte medium on Fabriano Artistico hot-pressed paper, 30" × 22"; 76cm × 56cm) I started with a light underpainting of Sennelier Phthalo Green, Phthalo Blue and Crimson. I then applied the matte medium mixture and let it dry. Next, I drew masks onto the surface and began to paint, lifting out, stamping, drawing with my brush, simplifying and deleting until the image appealed to me.

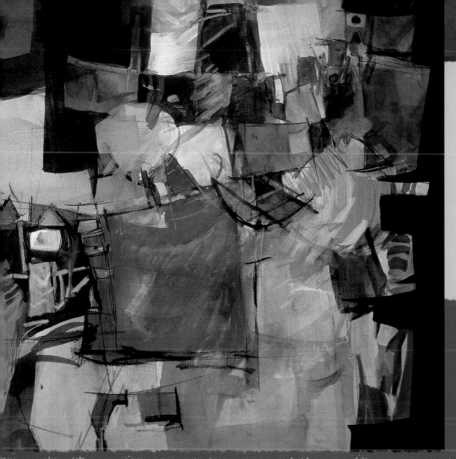

Homage to the Creative Square

"I never met a square I didn't like," Bob Oliver says, laughing. Sitting in his condo, he and I are surrounded by squares containing simple shapes and strong designs. Some are big, bold acrylic canvases, some exotically textured paintings on paper and some delicate, miniature collages. All have Oliver's unmistakable imprint of simplicity, elegance and tactile beauty. Earlier, as we had walked up to his attractive building, Oliver pointed out to me the strength of the square design. "Look at that!" he said, pointing to a square window that had a mullion separating the piece of glass into four more squares. "Even the numbers in the building's elevators are encased in squares," he

"The square symbolically refers to the number four and relates to the four Elements, the four seasons, the four stages of Man's life, and the four points of the compass."

⋙ J.E. CIRLOT ⋘

noted. Yes, dear readers, once you become aware of squares, you'll see them everywhere.

"Why am I attracted to squares?" Oliver ponders. "Perhaps it's because there are more design pos-

CHALLENGE

Paint Using a Square Format

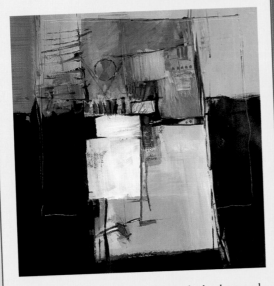

Start with a square format. Paint the background, then tear or cut color chips in different shapes and drop them onto the surface. Move the shapes around until you get a pleasant design. When you're satisfied with the pattern, remove the chips and paint in those squares, and if you get an artistic urge to add collage, do so.

A white rectangle dominates Bob Oliver's *A Square Deal* (acrylic on board, 14" × 14"; 36cm × 36cm), with calligraphic lines emerging dramatically from a muted series of rectangles and squares. Dashes of red in the circle and elsewhere add flair and contrast against the muted colors

his compositions, which are beautifully structured and composed, reflect all the concerns an architect would have with space, design and surface.

MULTIPLE INFLUENCES

"My architectural education coincides with the era of the Bauhaus and its International Style movement. In my paintings you'll find the influences of the legendary Bauhaus architect Ludwig Mies van der Rohe and the founder Walter Gropius. My education convinced me that less is more. Everything was to be structured and simple. I used watercolor to present my architectural projects, so I began to get to know the medium a little bit." Oliver smiles ironically as he adds, "Now, because of the computer, doing architectural sketches in watercolor is a thing of the past." As part of his training, he also had to learn to sketch both with a pencil and a pen, something he says paid great dividends once he began to paint more. "Drawing is the one way you can get an idea on paper, but it, too, is becoming a thing of the past."

Oliver, who travels extensively with his wife, Joanne, explains, "Generally my paintings of realistic subject matter come from my sketches, whereas my abstracts are a product of all the abstracts I've ever seen. As we walked through the great muse-

sibilities with two dimensions. At first I painted big squares—48" × 48" (122cm × 122cm) canvases. I rebelled against the rectangle, so I would chop off part of a half sheet of watercolor paper and make it square."

Angeles Arrien says in *Signs of Life: The Five Universal Shapes and How to Use Them* that the square symbolizes structure, security and solidity. I told Oliver that his attraction to the square is a direct link to his architectural background. In fact,

THE BAUHAUS INFLUENCE

Walter Gropius founded the Bauhaus, a design and art school, in Germany in 1919. According to Marilyn Stokstad, author of *Art History*, "The goal was a training of architects dedicated to a clear, organic architecture, whose inner logic will be radiant and naked, unencumbered by lying façades and trickeries." The Nazis, who considered the school avant-garde and dangerous, closed the Bauhaus in 1933.

ums of the world, the seed was planted, and I culti-vated it," he says.

After twelve years in the field, Oliver became a well-known and popular professor of architecture at Arizona State University. He credits two outstanding artists, Robert E. Wood and Rex Brandt, for contributing much to his artistic education. In addition, Oliver spent several summers studying at the Instituto Allende in San Miguel de Allende, Mexico, an educational experience that applied the final patina to his sense of aesthetics. In San Miguel, he learned his basic approach to painting, and at the same time became bored doing representational work. "Yeah," he laughs, "I said to myself, 'I can do that. What's next?'" With mixed media, Oliver found a new challenge. He's silent for a moment and then adds, "The bottom line is: I feel an inner urge—a search for something I can't quite articulate. I have a desire to take the things I know how to do and rearrange them in a new and different way! Of course," he smiles wryly, "the trick is knowing what to leave out and what to add."

A SQUARE START

Oliver describes his process this way: "I build a painting as a happening. I have no idea at the start what it will look like or what form it will take. I simply start with a color or two, and if I don't like it, I simply paint over it. Once I like the colors, I begin to add calligraphy or texture to excite the space. Then I might add other colors and shapes. It's an ongoing process that I can do for a little bit and then come back to in a half an hour and do some more. One thing leads to another. Every time I touch the surface, it energizes the painting and directs me to do something else. In that sense, no painting is ever finished. If I feel a piece needs more excitement, I turn to collage, which is always an exciting journey into experimentation.

"Sometimes a painting comes together all at once, and sometimes a painting has to grow from

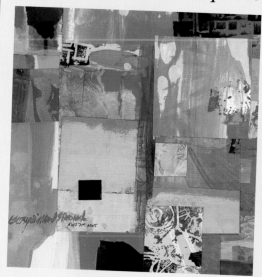

◆CHALLENGE

⇒Collage Squares Within Squares

Cut a big square out of an old painting (preferably one that doesn't work) and then cut other squares of different sizes and shapes from the remaining scraps of the painting. Collage these smaller squares onto the surface of the biggest square. If you need value or color change, apply opaque paint over the collage elements. Remember the importance of adding a neutral if your painting contains lots of color.

For *From One Square to Another* (acrylic and collage on paper, 22" × 22"; 56cm × 56cm), I cut out a big square from a painting that I didn't quite like and used it as my substructure. I glued an 8-inch (20-cm) square over the bigger square and glued other smaller squares over, and sometimes under, each other. After I had all the squares in place, I reinforced some areas by adding opaque orange. This painting can be viewed any way and work. I'm not sure I picked the best way! Oh, well.

no concept. And sometimes," he says, roaring with laughter, "a painting never sees the light of day." In the final analysis, he adds, "Sometimes you just have to run it up the flagpole and see if someone salutes."

The **Creative Now**

"By staying in the moment, you achieve 'at one-ness' with your painting. When you are at one with your painting, you're in that enviable 'gap,' where every brushstroke will have validity. Moreover, the images that emerge might surprise you."

⟩BETSY DILLARD STROUD⟨

Yikes! It's just hours before my demonstration for the Mid-Valley Arts League in Pasadena, California, and I haven't decided what to do. Should I whip off one of my signature still lifes? Or perhaps a cryptic abstract painted with bravado? How about a figure? No, I did that in San Diego last month. Suddenly it hits me. Why not simply paint where I am—literally and figuratively—a little uncertain and perhaps a little dazed from traveling?

I get the idea in a flash. I'm now in the moment, ready to begin my demonstration, and I start to draw. First comes an iris, a symbol for femininity I sometimes use in my paintings. Next, the ace of diamonds, a card I use to symbolize myself, followed by several other cards, an abstracted Arizona landscape to symbolize where I live, a nude (alluding to the fact that I am exposing myself by painting) and the number 9, which is the numerological year I'm in now.

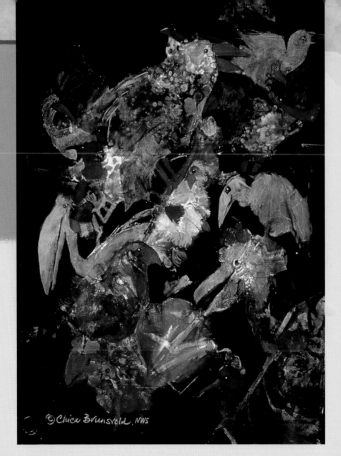

WHERE IDEAS COME FROM

While I struggled to decide what to demonstrate, I thought about where ideas come from. Are they floating around in space, just waiting to be grabbed and expressed? The answer, I think, is yes. Metaphysicians allude to "The Rain Cloud of Knowable Things," the source from which artists get ideas. We can always connect with the source if we stay in the now, in the moment, for there is an inexhaustible supply of ideas just waiting to take form. Here's how four artists, including me, paint in the now.

CATHY WOO PAINTS THE PRESENT

"As a painter, I often use the idea of the present as a building block for a painting," explains Cathy Woo. "Authors set the time and place of their stories from the very beginning. 'Once upon a time, in the land of such and such, there lived so and so.' And visual artists, whether they know it or not, do the same thing. Every painting is an externalization of the artist's internal sense of time and place, whether he/she is painting a landscape, a still life or a portrait.

"But what about abstract work? What is its setting? How does abstract painting convey time and place—or space? Although it may not be obvious, an abstract painter is often painting an internal sense of the present time—a present experience of color and shape relationships. An abstract paint-ing is the external, concrete evidence of an internal experience.

Putting together an abstract painting is really like stringing together a series of moments in time. Call each of these moments a metaphorical dot, and perhaps you begin to understand the nature of my *Connect the Dots* series. Each brushstroke was done in the present moment. Each dot was painted one dot at a time. The goal is to arrange the moments or dots into a coherent whole over the course of the time of the painting, so at the end the painting hangs together."

CHICA BRUNSVOLD GOES WITH THE FLOW

Chica Brunsvold's well-known *Zooillogicals* series has supplied her with years of creative challenges, encouraging her to search for images to develop in the process of painting. "I used to plan my paint-ings but found I lost interest in them when

Piecing Together a Story

In *Paths to Recovery* (mixed media and collage on paper, 15" × 22"; 38cm × 56cm), painted and torn papers stamped with writing represent letters and communication between Sandra Rooney and her husband. Torn sheet music, images of family, autumn leaves and fireworks all allude to intimate personal experiences they shared. The seeds and outer covering of the silver dollar plant represent birth and death, and the colored mesh a veil to hide behind. Images of a man with a large shadow depict Rooney's feeling of having lived in the shadow of her husband.

the problems were solved ahead of time!" says Brunsvold. "I'm usually happiest if I can find images, but if I don't perceive any, the painting remains nonobjective. If I do see something, I try to clarify the images so that others can see them, too. My brushstrokes are rather rhythmic and organic. Floral shapes sometimes develop. But if I work at it long enough, birds and animals appear to me, and I have fun turning the painting into a *Zooillogicals*, a term I coined to describe my strange and jumbled menagerie of animals and birds. My natural strokes just seem to suggest birds, and they most frequently find their way into my paintings!"

SANDRA ROONEY PAINTS WHAT SHE FEELS

Rooney expresses the now by using textures, colors and symbols to articulate her feelings. In a recent symbolic painting about her life, Rooney combined collage and color to explain her feelings about the death of her husband, Jim. "This painting arose from a motivation presented in an experimental painters' group and became a personal statement of the struggle with my feelings for my old life and my confused state of sadness and grief," she says. "I used light colors for joy and black for anger. What a wonderful healing experience this painting provided for me."

⬆CHALLENGE

⮑*Paint Wet-Into-Wet to Suggest an Essence*

Because drying time is anyone's guess, you have to stay "in the now" with the process to make your painting work. I use the wet-into-wet technique when I wish to produce ambiguous images, suggestions or essences of feelings or subjects. Try it yourself: Squeeze out fresh transparent watercolor (acrylic dries too fast). Completely and evenly saturate your paper with water. When the paper has lost some glisten, begin to brush in color. Vary brush size to vary the size of the shapes. Use thick paint when the painting starts to dry. Stop when the essence of something appears or when you feel the painting is complete.

To begin *Zen Iris* (watercolor on paper, 22" × 30"; 56cm × 76cm), I methodically wet both sides of a sheet of Fabriano Artistico soft-pressed paper with overlapping strokes of water using a 3-inch (8cm) brush. With a palette of Quinacridone Purple, Indigo, Indian Yellow and a bit of Crimson Lake, I then painted on the sopping wet surface. Floral images soon began to appear. I stopped while the image was still ambiguous, and yet the essence of an iris seemed apparent to me.

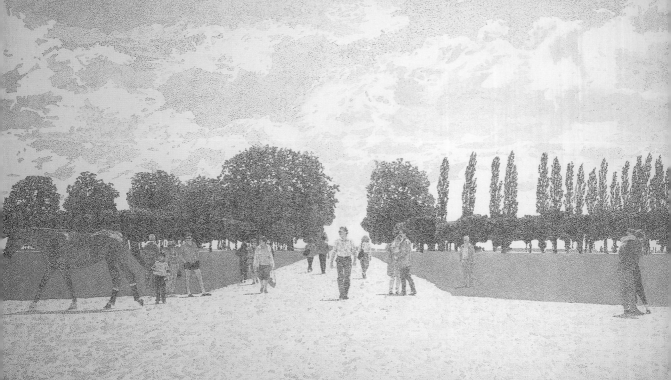

Moving On Creatively

The End of the Beginning
A Day at the Races (watercolor on illustration board, 25" × 40"; 64cm × 102cm) is one of David P. Richards' last fully realized Pointillistic watercolors. Although he returned sporadically to this style of painting, this painting represents the apogee of what he could accomplish with a Pointillistic approach. It was time to move on.

Most of us recognize the feeling immediately—a combination of restlessness, boredom and uneasiness. You may call it a block or a rut; you may say it feels as if you've run into a brick wall. Or you may simply acknowledge a vague feeling of inertia or an uncomfortable ambivalence that makes you question what and why you are painting. However you define it, there's a simple solution to this seemingly insurmountable problem. When you start to feel that your work lacks credibility, that's your cue to take a risk. In order to move ahead, you must move on.

A CASE IN POINT(ILLISM)
David P. Richards began his career creating work based on the concept of color mixing called Pointillism, the placement of dots of color that the

eye automatically blends—the results of which are incredible luminosity and vibration. And for a decade or more, his methodically rendered paintings earned him recognition and financial rewards.

"One day I started with a dab," says Richards," and it grew from one dab to another until I had a completed painting."With Pointillism, he says, "The first dot to the last must be absolutely correct in value and color, because if anything is wrong, the painting totally fails.

There was enough to challenge me with Pointillism that I stuck with it for the next decade, but eventually I needed to break away."

Richards began to expand his technique, exploring Pointillism from many perspectives. He tried masking out areas with frisket or frisket paper, and using Chinese White as a veil over parts of the composition; he tried working on textured paper and

CHALLENGE
Explore

Richards says, "Only through constant exploration can we express the ever-changing territory that is the artistic spirit within us." He challenges you to take an objective look at your body of work. Look for the connections in these paintings. Look for the brushstrokes, techniques, painterly qualities and other signature marks that make the paintings your own. Consider what the antithesis of your approach would be.

He advises you to "spend one week trying to capture what the opposite of your work might look like. For example, if your work is very detailed, spend the week painting just the hint or essence of a subject. If you work in a very realistic style, work on an abstract image

filled with color, light and movement. If your work tends to be small, paint something gigantic.

"We all have a personal approach to making art. It's up to you to take a deep look into your roots to look for your future. A week is not much time to explore. At the very least, you'll find it stimulating to go somewhere you've never been."

As Richards changed styles, he embraced total abstraction. In *The Construction of Matter* (watercolor and acrylic on paper, 22" × 30"; 56cm × 76cm), Richards departed completely from realism. In this painting, a contrast in both style and subject from his previous work, he strove to interpret time, space, energy, waves and particles.

leaving parts of the paper exposed to contrast with the painted Pointillistic areas. Yet the seeds of discontent had formed, and the gestation period for his new approach had begun.

A BREAKTHROUGH

Dismayed and at a crossroads, Richards decided to take classes with Michael Kessler, a non-representational painter known for his spontaneous, improvisational methods and expressive aesthetic philosophy. Kessler proved to be the catalyst Richards needed to move on. Studying with Kessler, Richards learned new techniques like layering and glazing and from them developed a different approach that still allowed him to set up exciting color juxtapositions but that involved an experimental element—a new way of applying paint. Richards' layering technique involves "pulling color."

His tools are simple: Stonehenge printmaking paper, sponge applicators and housepainting tools and brushes. To start, Richards mixes up a big puddle of thick paint with matte medium on a paper palette. With a scraper, he then transfers the mound of paint to his paper, smearing it on the surface, where he begins to manipulate it, building layers of color. Often he will have as many as thirty layers of color in one painting. At each stage, he moves the paint around, exploring the plasticity of the paint surface, creating texture in a variety of applications, using everything from brushes to cotton swabs. If a layer doesn't work, he keeps manipulating it until he likes it. Because of the matte medium, Richards is still able to use trans-

parent watercolors. The matte medium makes the watercolors become more malleable and gives him more time to move the paint around, resulting in lush color chords and an exciting painterly surface.

✒CHALLENGE

➣*Expand on an Idea*

Take an idea from a book or a well-known piece of art and make it your own. My inspiration came from an exercise in *Drawing on the Right Side of the Brain* by Betty Edwards. She suggests doing a contour drawing of a crumpled piece of typing paper. I expanded on that idea by crumpling up three pieces of paper to use as a big shape and a focal point for my painting. I then decided to surround that organic shape with geometric shapes to create a totally nonrepresentational painting.

Using red, blue and green Lascaux Perlacryl acrylics, I painted around the taped-out shape of crumpled paper for *It's Only Paper* (acrylic on paper, 30" × 22"; 76cm × 56cm). I then removed the tape and suggested the form of the white shape with a luscious gray, adding Titanium white to my mixtures and finished the painting by layering.

Resources and Recommended Reading

Not all of the titles listed below are still in print. If you can't find a title through a retailer, try the second hand bookshops and your local library!

THE CORE OF CREATIVITY

If You Want to Write: A Book about Art, Independence and Spirit by Brenda Ueland (Graywolf Press)

Carl Sandburg: A Biography by Penelope Niven (University of Illinois Press)

I, Dragon by Robert Joseph Ahola (Airleaf)

A CREATIVE JOURNEY THROUGH THE WRITTEN WORD

Rembrandt's Eyes by Simon Schama (Knopf)

The Moon's a Balloon by David Niven (Putnam)

A WALK INTO CREATIVITY

Drawing Closer to Nature by Peter London (Shambhala Publications)

JAZZ UP YOUR CREATIVITY

Dreaming with Open Eyes by Michael Tucker (Aquarian/Harper San Francisco)

Free Play: Improvisation in Life and Art by Stephen Nachmanovitch (J.P. Tarcher)

INSIDE THE CREATIVE RECTANGLE

Mondrian by John Milner (Phaidon Press)

Piet Mondrian: Catalogue Raisonné by Joop M. Joosten (Harry N. Abrams)

Complete Mondrian by Marty Bax and Theo Maedendorp (Lund Humphries Publications, Ltd.)

Piet Mondrian by Hans Ludwig C. Jaffé (Harry N. Abrams)

The New Art—The New Life: The Collected Writings of Piet Mondrian (Da Capo Press)

DOUBLE YOUR CREATIVITY

Discovering the Inner Eye by Virginia Cobb (Watson-Guptill)

COLOR YOUR WORLD CREATIVELY

The Art of Color: The Subjective Experience and Objective Rationale of Color by Johannes Itten (John Wiley & Sons)

Exploring Color (revised edition) by Nita Leland (North Light)

SHAPE UP YOUR CREATIVITY

The Shape of Content by Ben Shahn (Harvard University Press)

CREATIVITY: THE BLACK, WHITE AND GRAY OF IT

The Art Spirit by Robert Henri (Harper & Row)

Conjunctions and Annexes by Paul Jenkins (Éditions Galilée)

Color Choices: Making Color Sense Out of Color Theory by Stephen Quiller (Watson-Guptill)

HOMAGE TO THE CREATIVE SQUARE

Signs of Life: The Five Universal Shapes and How to Use Them by Angeles Arrien (Putnam)

Art History by Marilyn Stokstad (Prentice Hall)

A Dictionary of Symbols by J.E. Cirlot (Dover Publications)

THE CREATIVE NOW

The Power of Now: A Guide to Spiritual Enlightenment by Eckhart Tolle (New World Library)

MOVING ON CREATIVELY

Drawing on the Right Side of the Brain by Betty Edwards (Tarcher)

Conclusion

"You can tell whether a man is clever by his answers. You can tell whether a man is wise by his questions."

⇒ NAGUIB MAHFOUZ ⇐

Alice B. Toklas to Gertrude Stein on her death-bed: "Gertrude, Gertrude, what is the answer?"

Gertrude Stein's last words, "What is the question?"

It is now time to move on as you explore the ideas presented in this book. Enhance your ability to come up with new ideas by playing the accompanying game. Ask questions as you create. Find your answers by taking action and expressing yourself. Your conclusions will lead you to your next set of questions. There is, you see, no conclusion for the creative journeyer except to continue the journey.

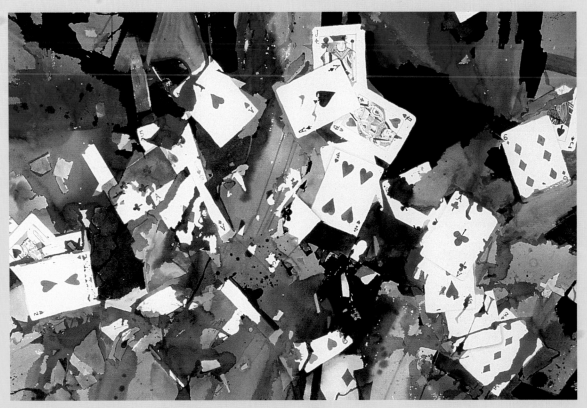

Mycroft's Glorious Gambit (watercolor on paper, 40" × 60"; 102cm × 152cm)

Game Instructions

I was born to play cards. The story goes that as I sat in my mother's lap at the age of three while she played bridge, I cried out at a critical point, "For Heaven's sake! Lead your ace of spades!" Naturally, my days as a tiny kibitzer came to a dramatic halt.

The love of cards has never left me, and they began to turn up in my art. The ace of diamonds, which is my own personal signifier, will appear in my paintings, as you may have seen in these pag-

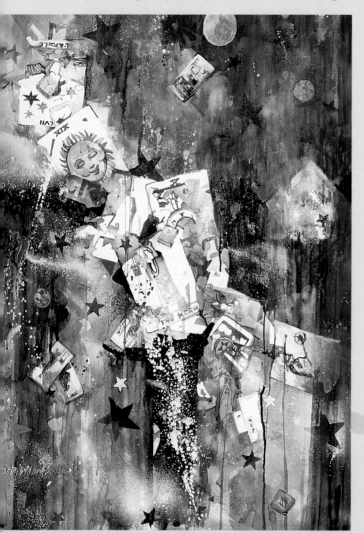

es. When I was commissioned to do a painting for the 1989 World Bridge Champion Bobby Haman, the fates couldn't have selected a more appropriate person to get the challenge. The result was my award-winning and signature series *Postcards from the Edge*.

Art and cards—to me the connection is natural, and now I'm solidifying the connection. I invented the following game to titillate, stimulate and challenge you to become more creative with your painting. When you're painting, drawing or doodling, remember: It's really only a sheet of paper, so have fun!

HOW TO PLAY

There are three decks of cards to choose from in this game. You may select one, two or three cards to create a painting. For example, choose a rectangular "Door" card, and create a painting based on that subject. If you wish, also select a "Circle" card, and execute your subject based on the color scheme on the back. Or really challenge yourself by drawing a card from the "Windows of Opportunity" deck. In this deck, you will find techniques and approaches designed to force you to think about new ways to begin a painting.

This game can be as simple or as complicated as you make it. Soon you will be tempted to invent some of your own challenges. Now, it's time to cut the cards.

Lost in the Cosmos

As a tribute to the late Walker Percy, one of my favorite writers, I did this painting named after one of his books. It's also a satire on all the "isms" that might confuse the average person looking for a spiritual path. After masking shapes with tape and wax paper (to save whites), I poured different hues of blue. When this step dried, I began to illustrate the cards, adding runes and other images to *Lost in the Cosmos* (watercolor and gouache on watercolor board, 40" × 30"; 102cm × 76cm).

Paint shattered glass or any other kind of glass arranged in an intriguing way. Will you make it realistic or abstract? Why not do it both ways in two separate paintings or combine the realistic and abstract in one painting?

2

CIRCLES OF GROWTH

Paint using only primary colors.

4

Circles of Growth
This deck contains various color schemes and ways of approaching color expressively.

WINDOWS OF OPPORTUNITY

Use drafting tape as a design tool. Start with a wet-into-wet underpainting (this layer will be your lightest light). After this dries, apply random shapes to your paper using drafting tape. Draw your subject and paint it. If you wish, add more tape as you go, or move the tape around as you add layers.

24

Doors of Awareness
This deck will empower you to develop your visions and goals about painting by exploring subject matter.

Windows of Opportunity
This deck challenges you with new techniques.

Index